Edited by Catherine McDermott

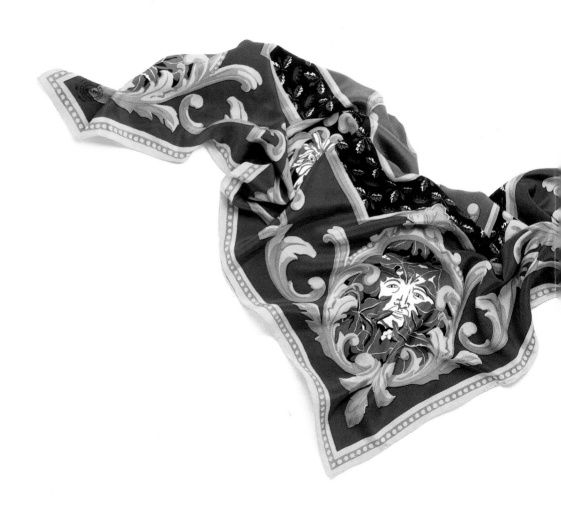

English Eccentrics

The Textile Designs of Helen Littman

To Judy

'For there is no friend like a sister
In calm or stormy weather
To cheer one on the tedious way
To fetch one if one goes astray
To lift one if one totters down
To strengthen whilst one stands.'
Christina Rossetti

Contents

Introduction Catherine McDermott 7

Chapter One **Fragments of Lost Time** *13*

Chapter Two **The Spirit of the Forest** *41*

Chapter Three **City of Monsters** *59*

Chapter Four **Freudian Slips** *73*

Chapter Five **Peace Angels** *97*

Curriculum Vitae 116

Exhibitions and Commissions 117

Introduction *Catherine McDermott*

Helen Littman's textile designs for the distinctly named English Eccentrics are instantly recognizable. Her trademark is a series of rich *trompe-l'oeil* scarves collected by museums such as the Victoria and Albert and illustrated by leading fashion magazines as an essential accessory of the decade. These professional fashion writers and curators share the view that Littman is one of the most original textile designers of the 1990s. Her designs have evocative titles like *Empire, Medusa* and *Ceres* and a firm of printers hand print the designs on flat-bed tables using no mechanical processes. The registration has to be exact and the particularly deep rich colours of Littman's original artwork are painstakingly reproduced. Each scarf, finished with hand-sewn rolled edges, is a carefully crafted art object.

Helen Littman's work is now at the centre of English Eccentrics but she has always worked as a team, primarily with her sister Judy. They grew up in the seaside town of Brighton where decoration and colour, from the Regency Pavilion to faded turquoise railings, were entirely normal. The two sisters progressed from nursery paper shapes through school art examinations to art college, Judy to study painting and Helen to train as a textile designer at the Camberwell School of Art in South London. At Camberwell, Joe Dixon was the course tutor. His educational vision was an unusual combination at the time. His course stressed the strong craft aspect of textiles but he also believed that art and design should be equal partners and from his inspirational department in the 1970s came a whole series of Britain's most successful textile designers. Joe Dixon's maxims shaped Helen Littman's approach to fabrics: 'He made me ask the question, "does the design enhance the cloth or is it better left plain?" And that is something I still consider'.

When Helen graduated in 1977, her first job was with someone who was to become another influential force on her work, John Miles, currently Professor of Fashion and Textiles at the Royal College of Art. He taught her the commercial lessons of designing at a time in the late 1970s when the business could be very tough indeed. A full-time job with a textile company in Islington brought home the reality of

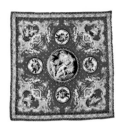

market forces. Whenever the designs looked too interesting the director would shake his head, look doubtful and comment, 'Think Wigan'.

Producing interesting, saleable textile designs in the early 1980s proved a long and difficult struggle. Working with friends and colleagues Helen printed up fabrics in a small workshop, made them up into garments and sold them at London's Camden Lock market. At that time Helen was reading a book by Edith Sitwell that her mother had lent her. The company needed a name, the title of the book was *English Eccentrics* and the two made a perfect match. They got their first break selling exclusively to a shop in the Kings Road called Academy. It was the summer 1983 and suddenly London became famous as the new centre for international style and ideas. The influential American trade paper *Women's Wear Daily* wrote a piece called 'London Swings Again' which featured their work. Suddenly English Eccentrics were writing orders with forward-looking buyers such as Jayne Harkness of Barney's and Barbara Gould of Macys. These were heady and exciting days for a company with an amateur status.

The sisters recruited an old friend, Claire Angel, recently graduated from St Martin's as a pattern cutter and fashion designer and this trio produced ten collections from 1984 to 1988. Suddenly they found themselves at the forefront of the English fashion explosion: alongside Katharine Hamnett, Joseph and Issey Miyake they opened a shop at London's Brompton Cross fitted out with bleached wood, a wrought iron arch and etched glass fittings. To complement the clothes they produced furnishing fabrics, stationery, hatboxes, soap and chocolate. It was terrific fun but within the new financial climate of the late 1980s it couldn't last.

In 1988 English Eccentrics decided to stop producing fashion collections and concentrate on a range of prints based on scarf squares that could also be translated into classic clothes. Their signature, strong print design, defined these garments. The design had to work as a placement print, with the centre of a scarf acting as the shirt back and the border design as cuffs and pockets. When a new design is completed a highly-skilled pattern cutter is brought into the studio to discuss the exact placement of

the pattern pieces on the fabric and each garment is then individually cut by hand. Every item is a complicated piece of craft work manufactured in limited quantities.

The same attention to detail is reflected in the printing process. A distinctive feature of Littman's work is the complexity of her techniques of mark making used in a single design. At English Eccentrics, all the printing is done by hand to obtain the most accurate screen fitting, essential to obtain complex *trompe-l'oeil* border effects such as shading on gilded frames. In a design like *Academy*, which combines flat painted screens, an outline screen, a textured screen and a photographic screen, screen making is all important. This is the point at which so many designs can lose the original qualities that make them so striking on paper. A screen has to be made for each colour and the translation is crucial, which is why Littman provides her own positives for each screen to retain every original mark.

Wonderful rich colour combinations have become a Helen Littman hallmark. To achieve these sumptuous effects, Littman prefers to use an acid dye range whose glass-like colours at their most intense remain pure, never become chalky when diluted and retain their clarity even when pale. Such pure translucent colour effects cannot be achieved with pigment dyes which are opaque like paint; acid dyes are more like ink and shown to best advantage on silk. Colour mixing is another vital element. The printers keep colour recipes for each design so that a re-print matches its original. The final consideration before a design is printed are the colourways usually available in three choices for each design. To maximize choice, colourways for each print are produced in different moods; a design originally painted in bright clear colours is also produced in sophisticated cool blues and greys, a third in ethnic burnt earth colours.

This array of colour and pattern choice is also the theme for the book. Each section explores a group of English Eccentric designs and looks at the sources and inspiration behind the work. Certain strands such as travel reoccur throughout, as well as wider issues which have shaped Littman's work. Her collection titles and choice of imagery reflect a commitment to social concerns – ecology, peace and the future.

'The past is a foreign country;

they do things differently there.'

L.P. Hartley

Fragments of Lost Time

For the designer, travel and the mass media as a means of opening up the world are irresistible sources of inspiration. The problem is that obvious cultural piracy is boring; what makes an exciting design is the element of surprise. Using easily accessible imagery from another culture can be an empty-headed exercise. In order to process the information in an interesting way, one needs to investigate the culture thoroughly. The only way to achieve a sense of discovery is through the first-hand experience of travel. Travelling makes one aware of the complexity of culture. Visiting another country, one absorbs a unique experience enriched by observing the effects of layers of time on its culture and artefacts. At the end of the 20th century, travelling around the world is possible for a large proportion of Western people. This has fundamentally affected our choice of artefacts and clothing, and has increased our awareness of the attention to craft in cultures not yet overrun with mass-produced objects.

Much of my design inspiration comes from my own 'Grand Tour' which has not been a single long journey in the 18th century tradition, but a series of short trips. On these visits I use a sketch book and a camera to record images, a habit acquired as a student at art college. I also make colour-notes whenever it is possible as local colour is never quite as enchanting when it is reproduced in books, postcards or photographs. Fragmentation of dissimilar images and their subsequent juxtaposition is a design method I often use when working with ideas observed on my travels. Fragmentation allows my work to reflect the weight of my own cultural luggage which inevitably colours my perception of other civilizations.

The visual images gathered on my travels form my own research library. They are sources that can be reworked and reorganized according to a design's requirements. Sometimes I might not work on the ideas from a particular journey for a long time, perhaps until another event revives the memory.

Holiday visit to the British School in Rome 1980

Everywhere there were the signs of age, the mixing of ancient history with modernity. The pillars of the Capitoline Hill showed this intentionally, their original remains being pale grey marble and the recently added parts being of red brick. The mosaics were beautiful, not just for their colour and the fluidity of their line, but also for their fragmented quality where time had erased some parts of each image, thus adding to their fascination. One's eye had to fill in the missing information. The backgrounds were not regularly laid like tiles, but flowed around the edge of each form as an Expressionist painter might depict the air around a tree. The small scale of the tesserae and subtle variations of tone were indicative of a highly-developed art form. By the Roman age there were thousands of different colours in opaque glass or marble for the mosaic craftsman to utilize. Mosaic images formed the border of the *Halley's Comet* scarf, designed to commemorate the appearance of the comet in 1986. Earlier I had designed a mosaic scarf printed by hand at college. But it was not until 1985 that I mixed the original mosaic border with a new centre to create the *Halley's Comet* designs. It follows mosaic tradition by placing a 'picture' within a mosaic 'frame'. In the centre a sun with a human face sits in the sky with the comet as it was drawn in the Bayeux tapestry and its Latin name. Modernity enters the design in the form of an astronomically accurate diagram which charts the comet's orbit. The design features both the wearing away of surface and the flowing background form of Roman mosaics. Around the borders are all the years of the comet's appearances from 1066 until 1986. The original painting of this design was in muted neutrals, but later colour-ways showed different moods, most notably the bright colouring which features a rich red sun in a shocking pink sky.

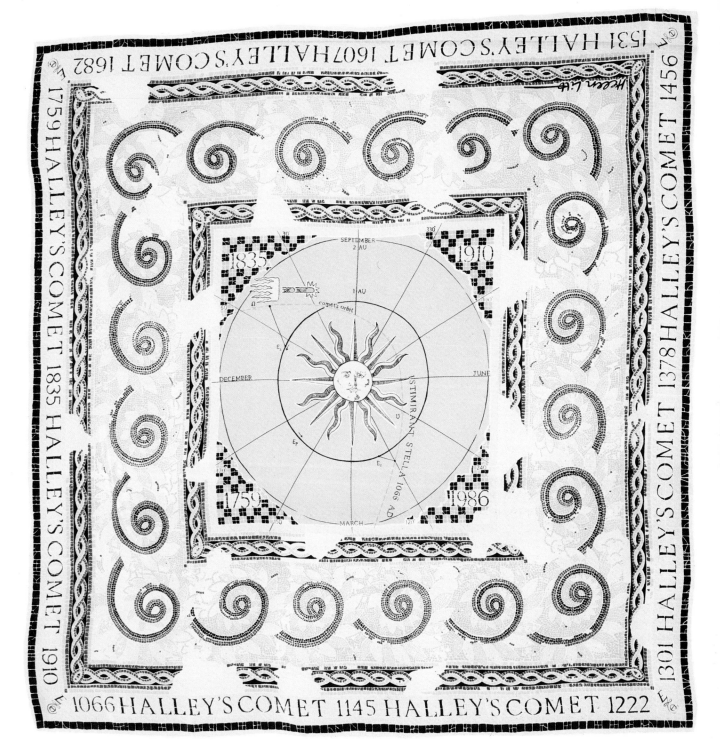

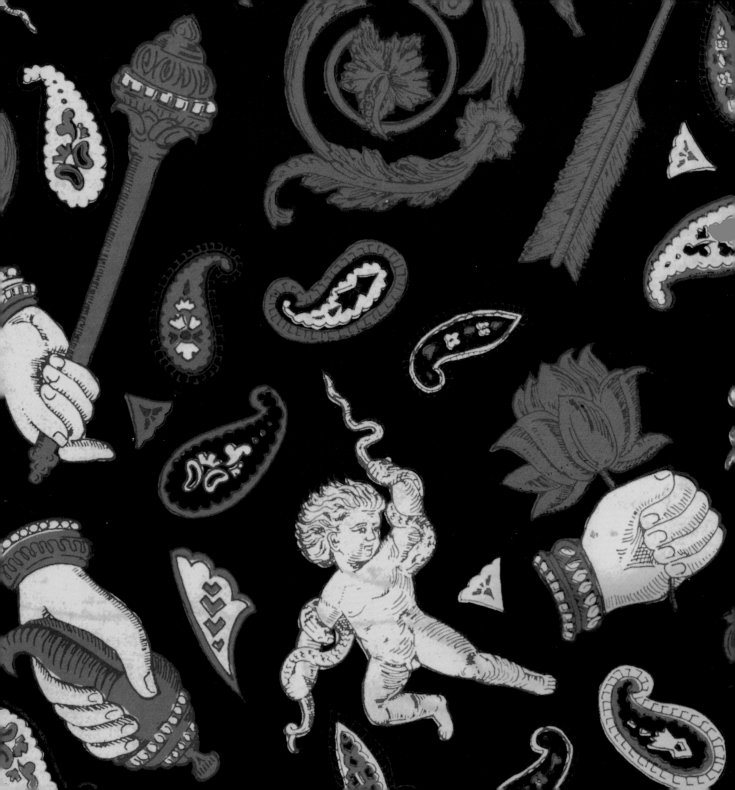

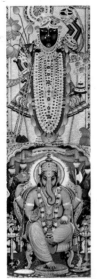

**Indian Border
Designed 1988
45 inch cotton
poplin, three
colours, three
colourways,
pigment dyes,
repeat size
48 x 114 cm.**

**following pages
Paisley Park
Designed 1988
60 inch cotton
jersey, four colours,
four colourways,
pigment dyes,
repeat size
25 x 56 cm.**

Holiday, Sri Lanka 1983

In Sri Lanka I came across the visual elements of Eastern religions for the first time. The Sinhalese were Buddhists. Their imagery included the famous Buddha's tooth relic which we visited in Kandy, the lotus flower which people laid at the Buddha's feet and the painted elephant who carried the relic around the town once a year. The second religion of the country is Hinduism, with an equally rich visual tradition as practised by the Tamil community. I was fascinated by the many attributes of Vishnu and Ganesh the elephant god.

Six years later my understanding was enriched by seeing Peter Brook's play *The Mahabharata*. In his epic reworking Hindu gods mix with mortals, and Ganesh narrates a part of the story. The play was the most visually stunning performance I have seen. It inspired *Indian Border* which features some of Vishnu's attributes: the conch shell, used for calling over very long distances, the holy lotus flower, and the deadly flying disc, which could decapitate its victims in an instant. A renaissance image of the young Herculese also appears in this design as both he and the young Krishna were believed to have subdued snakes.

Paisley Park takes it title from the song by Prince. It was designed for the same collection as *Indian Border*, and uses the same themes. Based on a traditional paisley pattern, the design incorporates images of Hindu gods, Ganesh and Vishnu, as depicted on Indian playing cards. A quality of rich embroidery is suggested by the use of metallic inks. The feeling of the design tied in with the hippy revival, Acid House style of summer 1989.

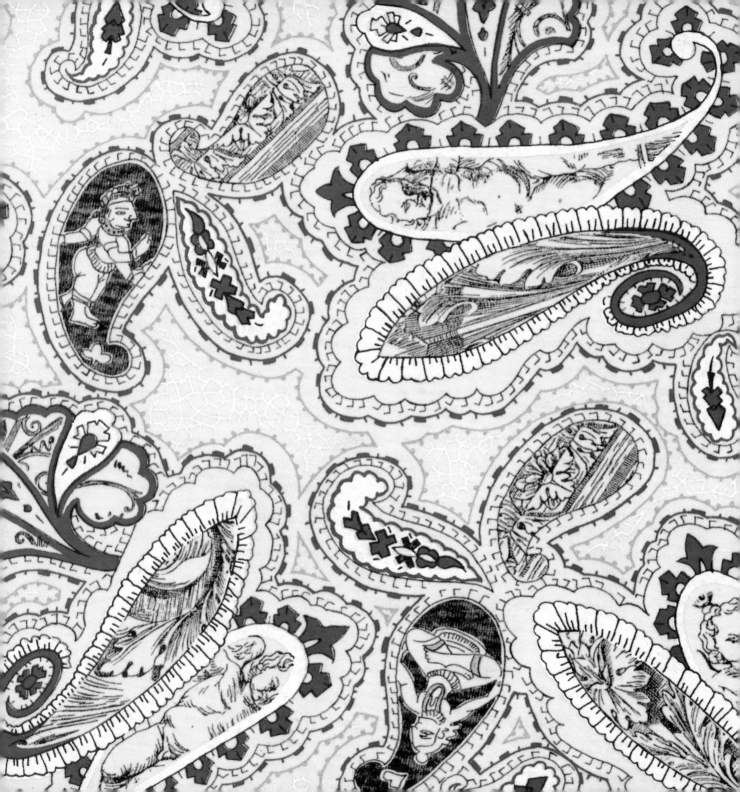

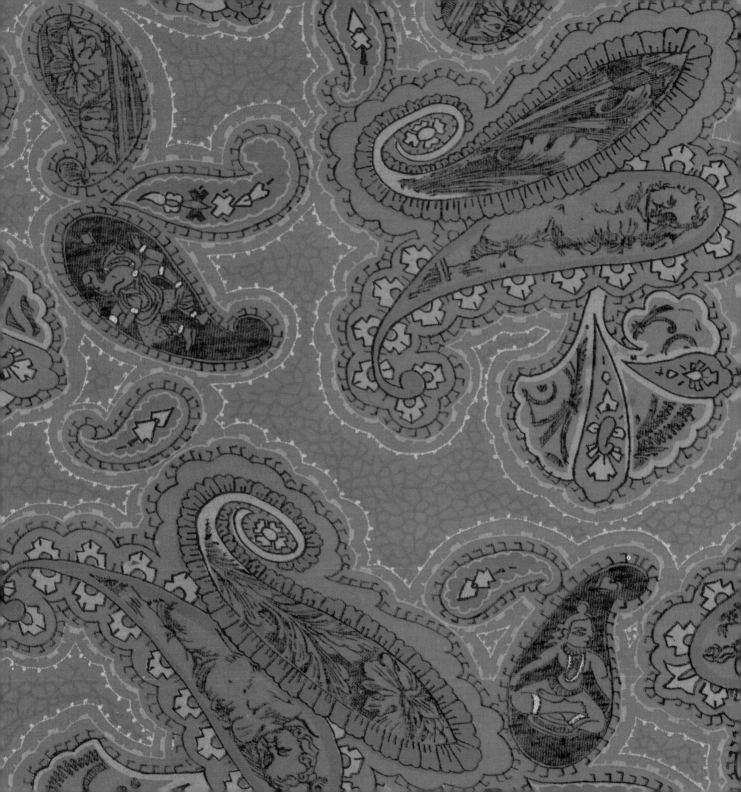

Barcelona drawing trip, June 1984

I visited Barcelona to study the work of Antonio Gaudi. Famous for his unique architectural vision, expressed in the still unfinished Sagrada Familia cathedral, Gaudi was also a master of mosaic surface decoration. Mosaics have always intrigued me, and his work in particular. As a free-lance designer I produced my first Gaudi-inspired collection from book research, but the desire to see this exceptional work at first hand remained. Gaudi's work can be seen throughout Barcelona, but the best examples of his colour sense are in the Parc Guell. This park is full of his inventive design, the serpentine walls a perfect vehicle for the mosaics of broken Catalonian ceramics, including both patterned and plain tiles and plates. This large-scale project was carried out with the help of architectural students. Gaudi was by no means a neo-classicist. His architecture was based on organic forms and the proportions of the human body, and his ideas are still ahead of the time. Colour was inseparable from form for Gaudi; he said that the sun painted the Mediterranean. His vision extended into stained glass, wrought iron and sculpture. A deeply religious man, he developed his own Christian symbolism and became a mystic. In old age he was often mistaken for a tramp.

 The ever-changing surfaces of the walls in the Parc Guell feature geometric patterns broken and reorganized into organic forms. In some areas whole shapes are defined by being devoid of pattern, in contrast to the rich patterning of the surrounding surface.

 My *Gaudi* design features images from the water-colour paintings I made of these walls juxtaposed with images of classical architectural diagrams. Printed on habotai silk, they formed the basis for a collection for summer 1985.

Gaudi
Designed 1984
36 inch silk habotai,
four colours, five
colourways, pigment
dyes, repeat size
50.5 x 90 cm.

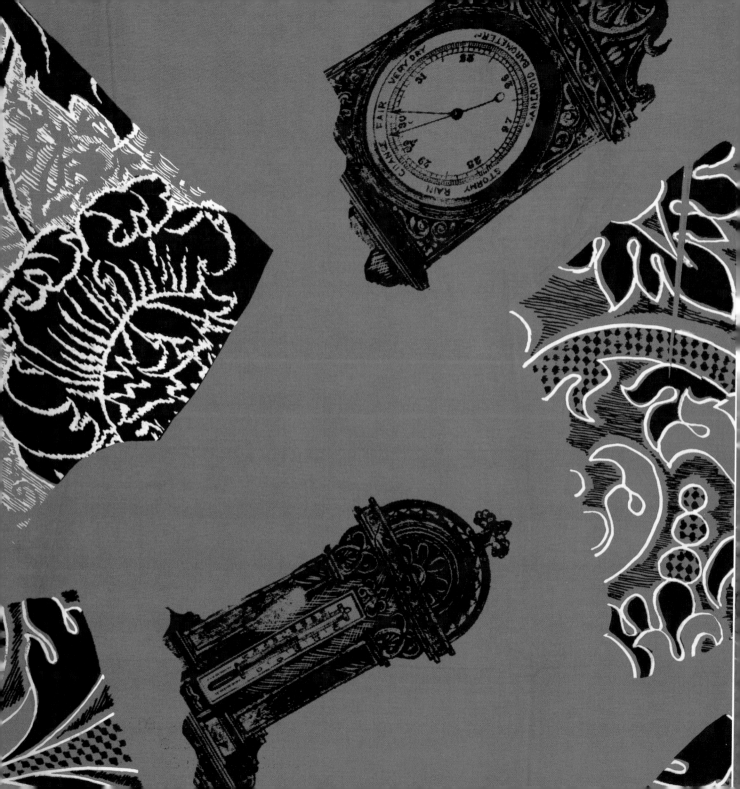

Arctic
Designed 1984
36 inch silk habotai
and silk organza,
two colours, five
colourways, pigment
dyes, repeat size
89 x 90 cm.

following pages
Polar Stripe
Designed 1984
36 inch silk habotai
and silk organza,
one colour, four
colourways, pigment
dyes, repeat size
7 x 19 cm.

Alaska stop-over: 'London Goes to Tokyo' designers' show, November 1984

This trip was carefully organized and sponsored by the Japanese branch of the American trade paper *Women's Wear Daily* and the Japanese cosmetic company Shiseido. In fact it had the feeling of a school outing gone berserk.

We spent a few hours at Anchorage airport where the plane refuelled. All around was the snowy landscape of Canada, but it might just as well have been the USSR. Looking at the map of our flight path, I realized for the first time how close the land masses of the two superpowers were. A giant stuffed polar in a glass case caught my eye. I thought about the Arctic explorers, and the drive which impelled them to leave the comfort of their Victorian drawing rooms for the extreme conditions of the Arctic circle. These images suggested the *Arctic* design. My first attempt was based on Victorian wallpaper, to suggest the explorers' homes, but looked too stiff and formal. I decided to tear up my original, adding barometers distorted on the photocopier to suggest the extreme weather conditions, and polar bears in icy landscapes.

Polar Stripe was designed to co-ordinate with *Arctic*. The design features tiny polar bears in a vertical stripe with snow flakes and lines to suggest woodcuts making up a textured background. The text in each border reads 'How to dress sensibly'. This was taken from a chapter in a 1930s book of Judy's about healthy living. The polar bear 'dressed sensibly' in his fur coat.

The *Arctic* collection was our first to be shown on the runways during British Fashion Week in March 1985. We printed on the bright habotai silks we had used for the previous two collections. Claire visited the Museum of Mankind for her styling, using the curved seams of the Inuit people's clothing. Judy based her stunning hand-knits on drawings of Inuit monsters and ethnic geometric patterning. For the finale we showed the prints on silk organza, with dried flower garlands in the models' hair.

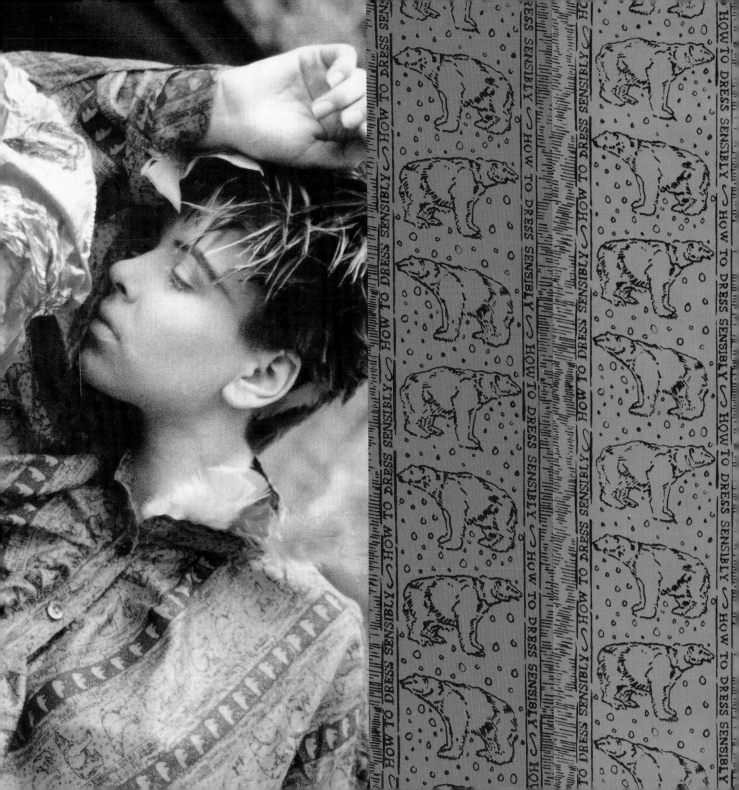

Los Angeles Fashion Promotion Trip, May 1985

Keoma, a middle-market company based in Hong Kong and the USA, invited Judy and I to New York and Los Angeles to promote a collection we had designed for them, and to learn about the American market. Beverly Hills was a revelation. We left the comfort of our astroturfed swimming pool area to explore downtown LA. The Mexican market at Almeira Street fascinated us: we bought brightly painted candlesticks and wonderful playing cards with Spanish captions, illustrated in a 1940s, slightly naive style. These images – including a star, a man holding the world, a mermaid, a skull and a spider – seemed like an alternative Tarot.

A completely different visual direction in the USA was the interest in Shaker furniture and the beauty of Amish quilts. On our return to England we visited the American museum in Bath to further our research into quilts, and this resulted in the *Southern Comfort* collection.

A print of the same name was based on the design of a traditional Amish quilt pattern, called 'robbing Peter to pay Paul', where each square has a corner cut off with an arc, and where four arcs meet a windmill shape occurs. Over this background, which I allowed to disappear in places to suggest the idea of an heirloom, images from the Mexican playing cards were placed. The colours were taken directly from the faded vegetable dyes of the original quilts.

The second print inspired by our California trip was *Signatures*, a simple stripe made up of the signatures of the English Eccentrics design team. Our signatures were included alongside those of famous Mexican revolutionaries and people whose flamboyant handwriting we admired. In between each row of signatures a line is drawn to suggest a leaky pen.

Claire's garments for the *Southern Comfort* collection were based on Latin American and flamenco silhouettes.

Signatures
Designed 1985
36 inch linen and 36 inch silk twill, one colour, three colourways, reactive dye and acid dye, repeat size 25 x 15 cm.

following pages
Southern Comfort
Designed 1985
36 inch linen and 36 inch silk twill, five colours, two colourways, reactive dyes and acid dyes, repeat size 82 x 92 cm.

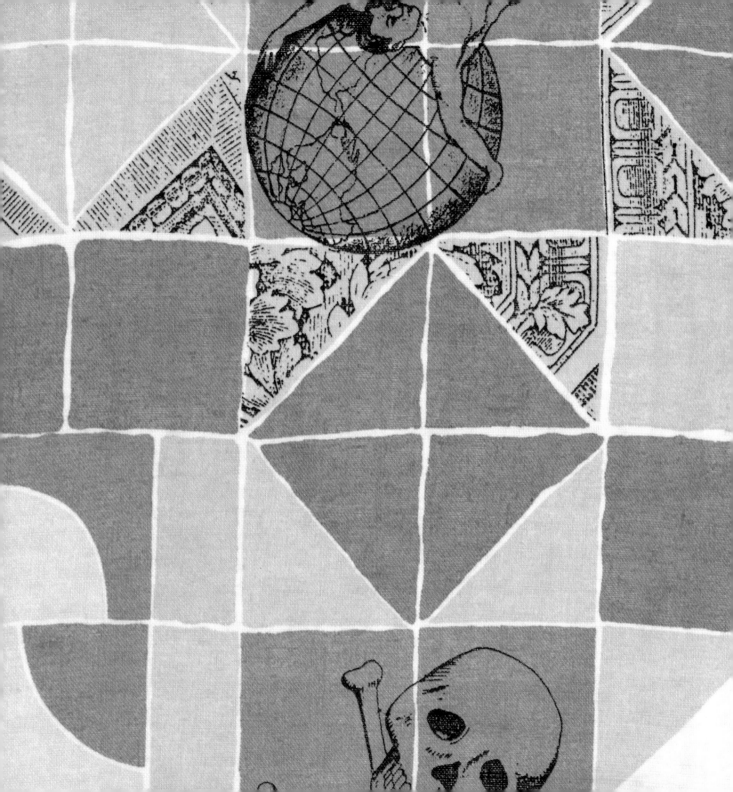

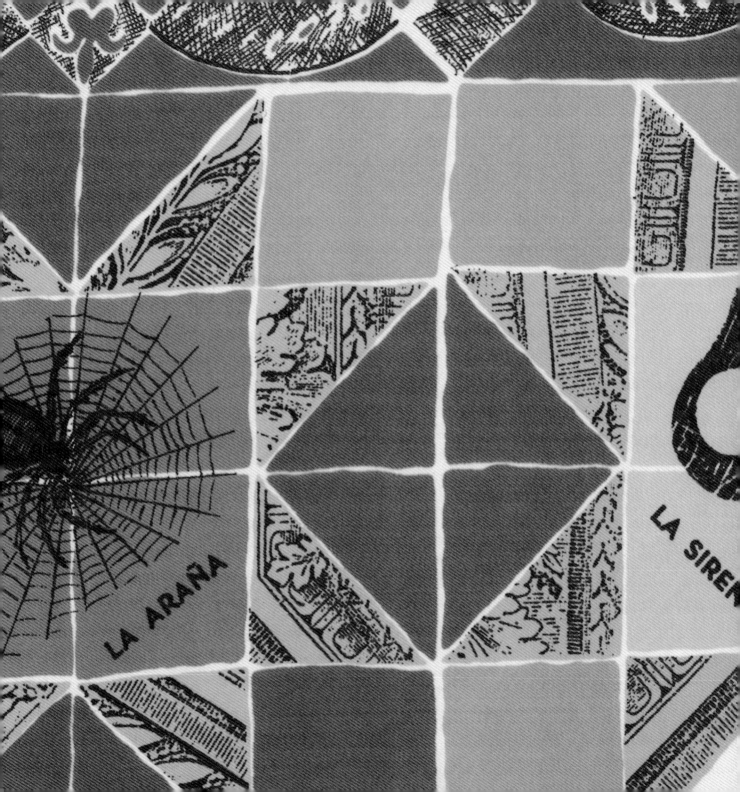

Rosettes
Designed 1987
36 inch silk habotai,
three colours, three
colourways, acid
dyes, repeat size
33 x 30.5 cm.

following pages
Venezia
Designed 1987
60 inch cotton
jersey, five colours,
four colourways,
pigment dyes,
repeat size
95 x 75 cm.

Venice research trip with Claire Angel, May 1987

Venice became the starting point for our collection for summer 1988. One of the world's most beautiful cities, Venice conjures up images of romance, decadence and lost glory. Where does one start? Perhaps in the most obvious place, we sketched and took photos in the Piazza San Marco. We visited the Ca' d'Oro with its ornate plasterwork and saw exhibitions about Archimboldo and Commedia dell'Arte. We came across a series of stunning frescoes featuring Punchinellos in a variety of scenes. The colour was always muted, dirty pinks, blues and neutrals. This work might well have inspired Picasso and his contemporaries in their fascination with characters from Commedia dell'Arte.

As the collection was to feature body-conscious styling we printed the main design on cotton jersey. Because of the inflexibility of pigment colours, I had to ensure the print was sufficiently spaced to allow a lot of stretch.

The *Venezia* print features the lions and astrological clock in the Piazza San Marco, and local details including carnival masks, gondolier posts and the plaster of old palaces. The crumbling facades of the exteriors of many buildings provided the dirty pale pink of the background for one of the colourways, the mystery of the canals by night the dark navy for another.

Rosettes was the silk print for our summer 1988 collection. *Rosettes* is based on the costume of the gondoliers, their striped T-shirts and decorated boaters. It is a *trompe-l'oeil* design with rosettes standing out against a stripy background. Co-ordinating with this print was Judy's striking hand-knit *Venezia*. On a base of navy and white stripes she added a garland of colourful flowers; at the neckline the word 'Venezia' was picked out in French knots. Claire based her garments for the *Venezia* collection on Commedia dell'Arte costumes and court ballet.

Empire
Designed 1989
45 inch crepe de
chine, nine colours,
three colourways,
acid dyes, scarf
format.

Paris holiday with Colin, September 1987

Colin and I love Paris, and visit the city as often as we can. Some of its most impressive architecture comes from the formal grandeur of the Napoleonic era; the wide roads, the imperial eagles on the Pont D'Iena, the gilded, claw-footed furniture in the grand old hotels. On this trip we discovered the Marche aux Puces and found some fine examples of Napoleonic antiques. Lions, eagles and sphinxes supported furniture and candelabra, curtains were tied back with gilded rosettes, and marble table tops supported by eagle wings. These discoveries inspired the *Empire* scarf. This scarf creates clothing with a very strongly engineered distribution of pattern. Its basic format is a star within a circle within a square. *Empire* has a spacious formal layout, sphinxes in each corner and gilded rosettes at the centre of each side. A wreath of olive surrounds the centre, which features eight mermaids arranged symmetrically around a star. Each area is separated by a border of marble, the outer border formed by a gilded egg-and-dart cornice. Most classical mouldings have a symbolic meaning, and the egg-and-dart is no exception, referring to life and death. The original painting for *Empire* was the turquoise colourway. This colour was popular in interior design of the period, and has not been seen in interiors since, except for a brief appearance as plastic in the 1960s.

 The gilded effects in this print are in the brightest golden yellows of any of my designs, and their strength along with the boldness of layout suggested that this design should only exist in very strong colourways; the other choices being red or black.

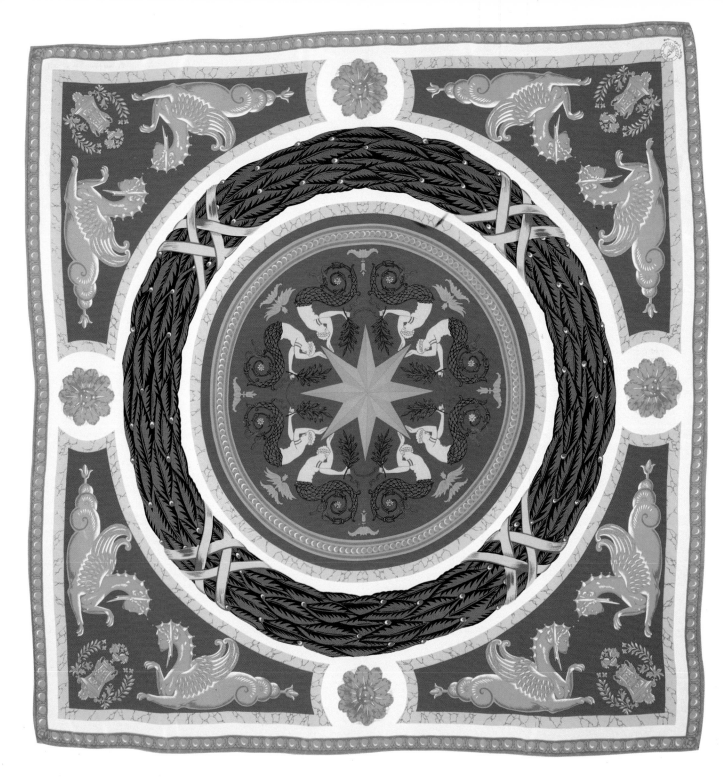

Bangkok holiday with Colin, January 1988

After a business visit to Tokyo we stopped off for a few days in Thailand. We did not know quite what to expect and were amazed by the Thai attention to beauty in design and their skills of presentation.

Tassels made of intertwined jasmine flowers that women would carry in the evenings, and intricately carved vegetables in our soup and the rose-carved watermelons made us feel clumsy in our attempts at floral and culinary decoration.

We were very impressed with the colour of the wonderful floating marketboats, the Bhuddist monks' saffron robes and the elaborate decoration of the dance costumes. We visited a temple where an enormous sleeping Buddha had feet inlaid with mother-of-pearl. The walls were stencilled with boldly coloured floral designs and were being restored by a group of art students. Pattern was everywhere, a natural expression of the beauty that the Thais find in everyday life. Patience and skill were to be seen in everything.

In the evenings we watched the traditional dancers performing at a cultural centre. Colours were mixed in dazzling groups with complex detailing and rich embroidery. Some dancers had very long metallic nails, and all were heavily made-up. The tall pointed head-dresses evoked the temple architecture we saw during the day.

Visiting some of the many temples in Bangkok, I was surprised to see one, the Wat Arun, that evoked the work of Gaudi. Patterned plates had been broken and reassembled to form thousands of flowers around the base of the temple. Their edges were irregular, but each form had the feeling of a petal; the outer edges extended out from the plaster supporting them which gave a three-dimensional effect. The *Thai Flowers* print was inspired by this visit. The patterns used for the torn petals were not of Thai origin, but were Western (e.g. from wrought iron) to add a twist to the idea, however the base silk and palette reflect the vibrant use of colour in Thailand.

Thai Flowers
Designed 1988
45 inch Thai silk,
three colours, four
colourways, pigment
dyes, repeat size
35 x 35 cm.

'Of all the trees that grow so fair,

Old England to adorn,

Greater are none beneath the sun,

Than oak and ash and thorn.'

Rudyard Kipling

The Spirit of the Forest

Britain was once an enormous forest. Pub names like the 'Green Man' recall an England of secret rituals and traditions, prehistoric stone circles and ancient forests. Who or what is the green man and why is he so ubiquitous a presence? The green man is the spirit of the forest. His leafy face is carved in many medieval churches throughout England and northern Europe.

His origins, however, pre-date Christianity by many centuries. Serious interest in this period was revived by Victorian writers such as Sir James Frazer. In his rather romantic book, *The Golden Bough*, he pointed out the prevalence of tree worship in Northern Europe. Fifty years later, Robert Graves, in his book *The White Goddess*, put forward the theory that the early Celtic religion that we now refer to as Druidism, was centred on tree worship. The cutting of mistletoe from the oak tree with a sickle was symbolic of the act of castration needed to allow new life to flourish. Graves suggested that this ritual derived from the Greek myth of the castration of the father (Uranus) by the son (Cronus) at the request of Mother Earth. In Celtic mythology every type of tree in the forest had its own meaning.

When England became a Christian nation, the old ideas were too deeply ingrained in the collective psyche to be effectively suppressed, so they became incorporated into church architecture. The best way to encourage the uptake of a new religion was by incorporating the symbols of the old order into its iconography. This is why the head of the green man is seen in so much church architecture and why there are so many heads used as bosses and at the top of posts. In William Anderson's recent book, *The Rise of the Gothic*, he asserts that the severed head was an ancient symbol of good luck and acted as a protection against evil. This possibly developed from an era when decapitation was a part of religious sacrifice.

My interest in the spirit of the forest was aroused by the hurricane of 1987. I was, along with many others, shocked and saddened by the destruction of so many trees. The idea that some of them were many centuries old encouraged me to explore

**Spirit of the Forest
Designed 1987
45 inch crepe de
chine, seven
colours, three
colourways, acid
dyes, scarf format.**

not only the mythology of trees but also the culture of British folklore.

Many old English traditions are as ancient in origin as the green man. On holiday with our friend Simon, who has a cottage near Dartmoor, we witnessed one particularly striking annual event held in November in Ottery St Mary, Devon. Called 'tar barrel rolling', it involves the young men of the town (and recently women too) carrying a barrel of flaming pitch on their shoulders through a dense crowd. The barrel is passed from one man to another, and is very heavy, so the carrier stumbles about erratically under its weight, until it becomes too hot to handle and is dropped. The machismo is partly in the showing off of burns the next day. Among the procession which precedes the rolling were some striking mummers, their faces blackened as a sign of anonymity, their clothes disguised with strips of fabric, and their hats decorated with foliage.

Two thousand years of Christianity cannot eradicate the pagan in us. The Avebury circle and Stonehenge are among the most powerful sights in England. Pagan images can be seen on several hillsides; it is probable that the forest was especially cleared in these areas to enable their originators to carve into the limestone. Of these enormous white-on-green images, the most familiar is the Cerne Abbas giant. Holding a club in one hand, the giant has an erect penis which for many years was covered over with foliage by nearby monks. Presumably he was used by the ancient British as a centre for fertility rites.

In medieval times when the green man was a popularly accepted image, the spirit of the forest was very strong as a theme both in decoration and in literature. Acorns were used as a motif in many embroideries. Motifs from the forest were incorporated into church architecture and the heads of forest animals decorated homes. The forest was all around, a universal setting for people's lives. It was the source material for the Robin Hood stories even though in reality the forest was controlled by the king and the nobility. They appropriated forest animals as symbols of power and

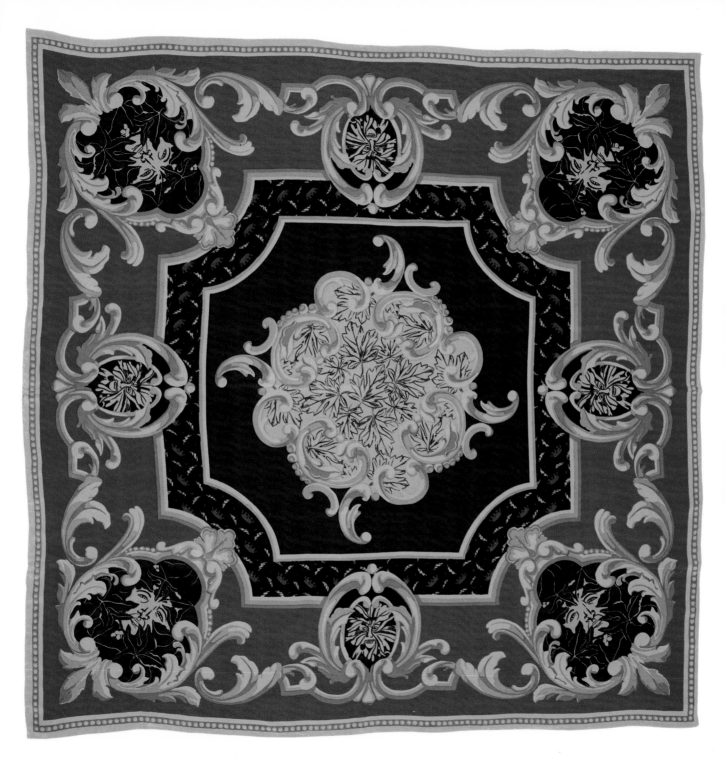

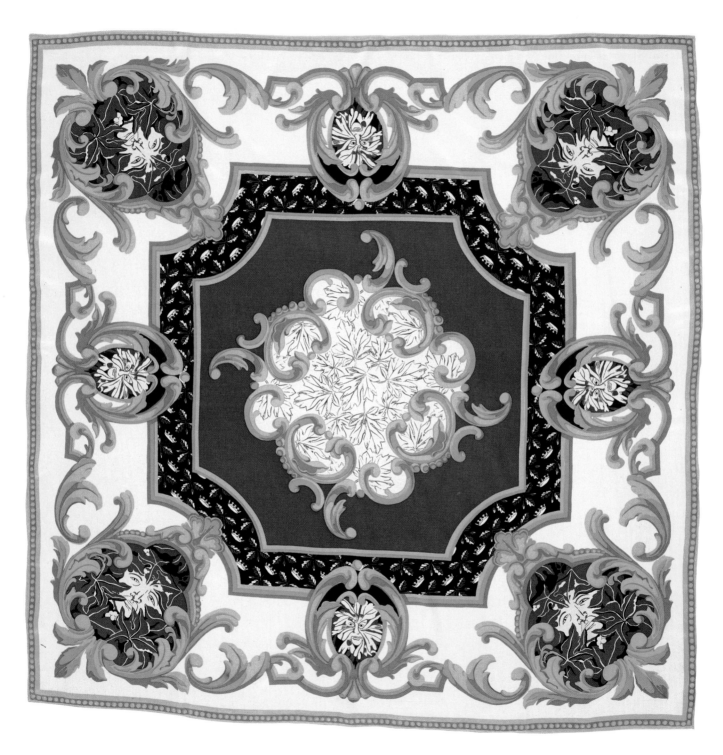

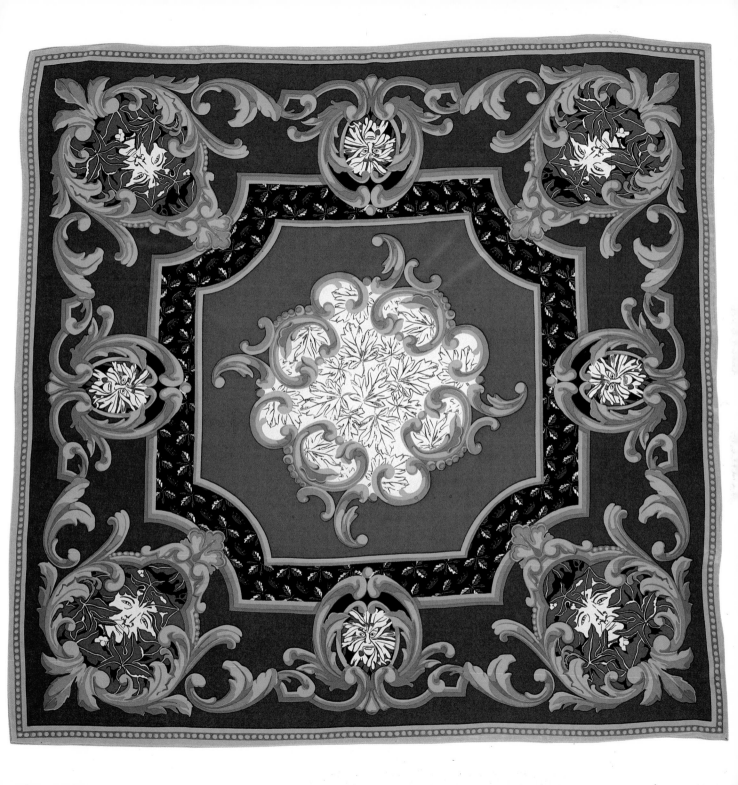

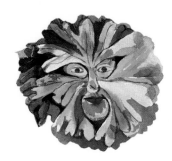

Beasts of England
Designed 1987
45 inch wool challis
and 45 inch crepe
de chine, six
colours, six
colourways, acid
dyes, repeat size
79 x 114 cm.

following pages
Woodblocks
Designed 1987
36 inch silk twill and
60 inch cotton
poplin, six colours,
six colourways, acid
dyes, repeat size
13 x 12.5 cm.

authority. Swans, boars and stags were commonly used in heraldic devices.

The richness and sophistication of medieval art were displayed at the *Age of Chivalry* exhibition at the Royal Academy in summer 1987. The exhibition was a revelation, the delicacy of the metal-work, the rich colour of the stained glass and the power of the iconography were irresistible as the basis for a new collection.

The *Spirit of the Forest* collection was designed for winter 1987/8. The theme was to mix the styling of the 1940s and of the medieval period with a slightly tongue-in-cheek Robin Hood influence. For the first time we decided to use the colour green – although traditionally considered unlucky, green has recently become more popular as a part of the ecology mood in 1990s fashion.

The *Spirit of the Forest* scarf features two images of the green man, both based on existing church architecture. The larger face, based on a carving in Dijon Cathedral, has leaves coming out of his mouth and forehead, the smaller face, based on a painted wooden boss in Norwich Cathedral, is entirely composed of leaves with features just appearing. Between the border and the centre of the scarf is an area patterned with crowns and acorns, symbolizing the oak as king of the forest. In the centre of the scarf are some simply drawn sycamore leaves. The gold borders and general layout are based on an Aubusson carpet. I juxtaposed these images to play upon the contrast between the sophisticated Baroque ornamentation and the more organic medieval imagery.

The idea of the *Spirit of the Forest* sweatshirt design was to create a heraldic style image to complement the collection and embrace its themes. The design features a unicorn from the *Beasts of England* print, one hand holding a sword and another a scythe over a golden oak bough. On the side there are little drawings of mistletoe and acorns, a reference to Druidism. Under the central shield are three images of the Cerne Abbas giant.

The *Beasts of England* design features animals with a royal connection: swans,

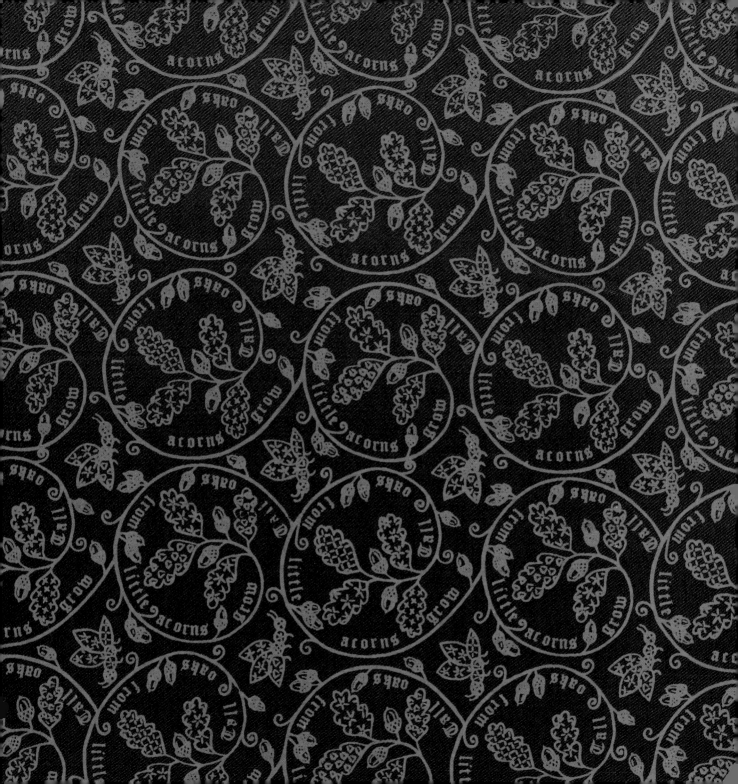

deer, wild boar, and the mythological unicorn. The animals and some decorative circles are arranged over a background broken with heavy black lines suggesting stained glass. Colours were inspired by the *Age of Chivalry* exhibition at the Royal Academy, especially the stained glass of the Prophet Isaiah window from Exeter Cathedral. The colourways were gentian violet, old gold, burgundy, forest green, rusty red, teal.

Woodblocks is a small-scale all-over, also from the *Spirit of the Forest* collection, designed in the style of 1940s prints when a space had to be left between the images and the blotch (background) to keep colours from running. The images are based on old woodblocks of medieval subjects; a knight in armour, a crown, a mermaid, a sow, a sphinx, an egg, a water-carrier and the figure of death with a small boy. The colourways are brown, black, forest green, rusty red, teal, gentian violet.

The *Acorns* design is a small-scale one-colour print in raised dyestuff, based on Elizabethan black-work embroidery at the V&A. To imply an embroidered fabric I used tone-on-tone colouration. The acorns are surrounded by a line from a poem by David Everett (1769–1813) written for his school declamation – 'Tall oaks from little acorns grow'.

The imagery of alchemy has fascinated me for a long time. The idea of the transmutation of metals from base to pure, mirroring the spiritual transformation of an alchemist from a rudimentary creature into a being with higher knowledge, is the basis for this secret art which preceded chemistry. Because the exact meaning of the symbols is unclear, one attempts to work out a meaning from the strange juxtapositions of animals, planets, elements, people and colours.

Plants become animal, with human or sun faces, a body sprouts the heads of a man and a woman, Mercury and a rampant lion stand outside a kiln. The complexity and obscurity of these images both attracts the outsider to an interest in the Great Work, and at the same time repels her by their very impenetrability. In this design I have used some of these strange images in a straightforward way, because some

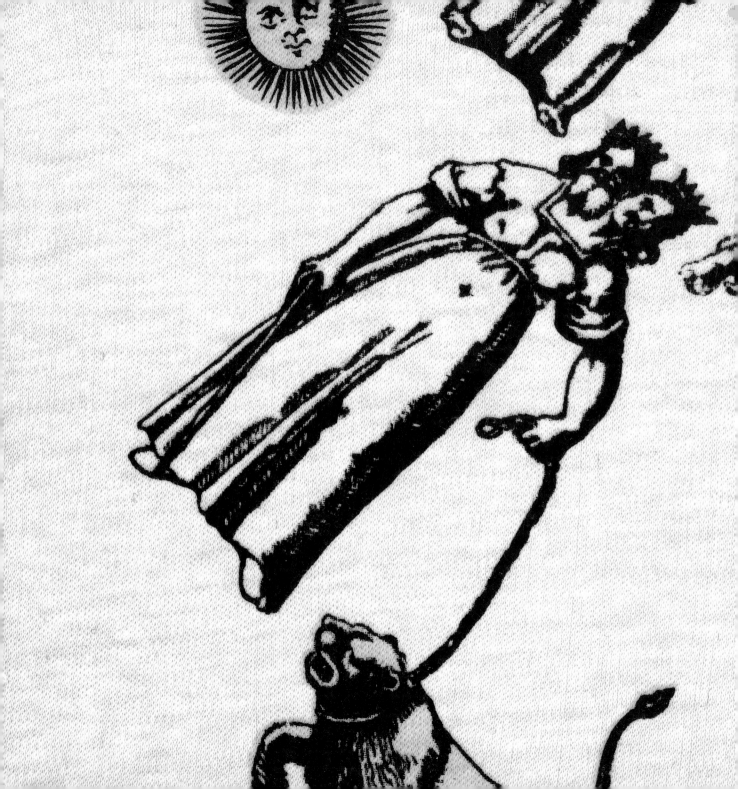

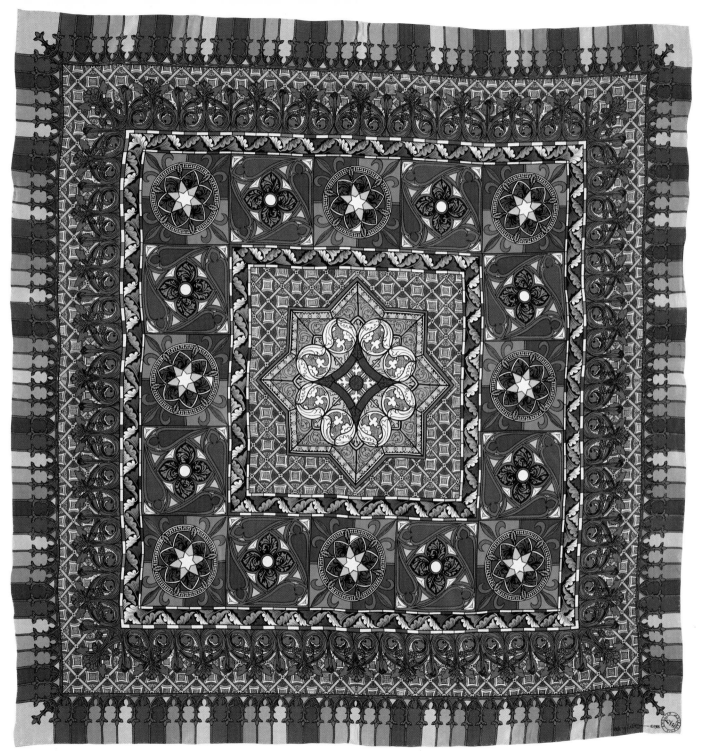

'found' images are more powerful if left alone.

 Stained Glass was also inspired by the *Age of Chivalry* exhibition. The colours reflect the intense luminosity of old cathedral glass and the contrast between the highly coloured areas, which were generally representational, and the areas of clear glass where geometric pattern was created by leading called 'grisaille'. The border pattern is derived from Cashmere shawls and incorporates all the colours of *Stained Glass*.

Stained Glass
Designed 1987
45 inch crepe de
chine, six colours,
three colourways,
acid dyes, scarf
format.

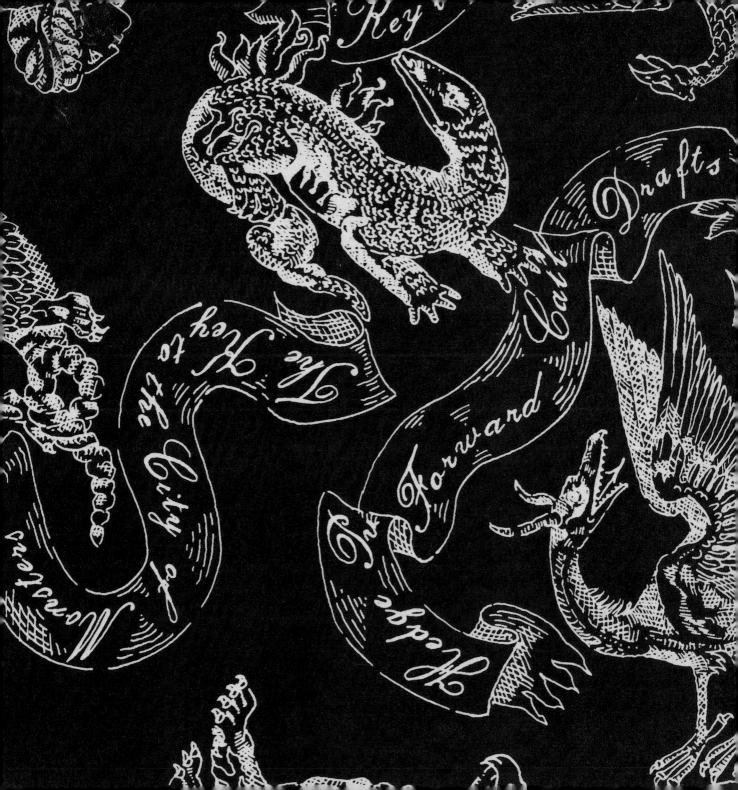

'Despising, for you, the city,

thus I turn my back:

There is a world elsewhere.'

Shakespeare, *Cymbeline*

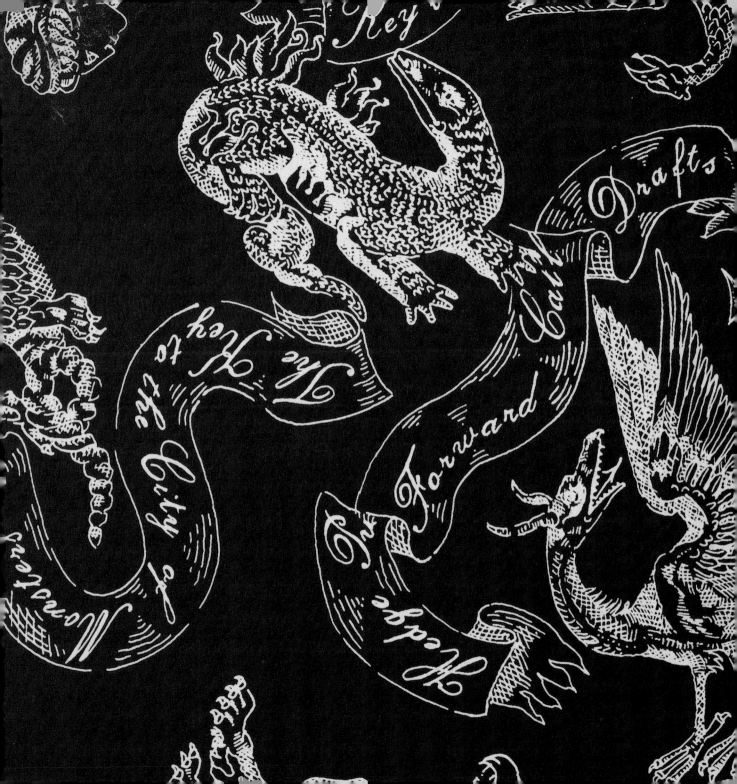

City of Monsters

City of Monsters
Designed 1986
36 inch habotai silk,
one colour, three
colourways,
discharge dye,
repeat size
70 x 112 cm.

following pages
Crewel Monsters
Designed 1986
60 inch cotton, three
colours, two
colourways, hand-
embroidered crewel
work, repeat size
93 x 136 cm.

Sometimes in search of inspiration, I wander through the City only one mile from our Victorian brick studio in Shoreditch. I enjoy the wonderful mêlée of styles including the new post-modernist buildings with patinated metal surfaces at Liverpool Street Station, Richard Rogers' controversial Lloyds building, Sir John Soane's neo-classical Bank of England, the hideous Barbican Centre of 1960s brutalism, the decorative Victoriana of Leadenhall Market, and the ancient splendour of the Tudor City walls, at St John's Gate.

The City of London has its boundaries marked by carved stone monsters, somewhere between dragons and griffins; they hold the shield of St George. Inside the City live creatures of a different kind. A new breed known as yuppies.

Behind smart City facades these young men and women play with billions of pounds. What is my interest in them? The fact that many are young and wealthy makes them newsworthy. In the Thatcherite 1980s they represented an ideal image to aspire to; Filofaxes, Mont Blancs, Raybans and all. Advertisements abounded with yuppie stereotypes – the perfect consumers for us to love or hate. As potential yuppies, we were offered improved financial services. Bank managers popped out of our wardrobes and independent financial advisers appeared on the corner of our street. We were encouraged to collect credit cards, guzzle champagne and spend money as though it was going out of fashion, which, in fact, it was. Finance and commerce hold an uneasy fascination for many designers. Artists and craftsmen need patrons despite the tendency of the former to bite the hand that feeds them. In the late 20th century this financial relationship has changed fundamentally. Art and design are now seen as having tremendous market value. The culture of design has been picked up by the City.

The City is a world of stockbrokers, money-dealers, commodity brokers, bankers and the occasional corporate raider. International trading has been speeded up by the introduction of modern information technology. The financial day begins in

Tokyo, moves on to London and winds up in New York. This world, mysterious to outsiders, with its own complex rituals and practises, inspired the *City of Monsters* collection. The timing of the collection proved to be rather dramatic, coinciding with the big crash on 19 October 1987, known as Black Monday. Since then the world of high finance has lost its sheen, with the fall from grace of New York's Junk bond traders and the Guinness trials revealing questionable business practise in London.

The title design of the collection, *City of Monsters*, combined medieval iconography from the City, with financial jargon. Griffins, salamanders and sphinxes are drawn in a linear style with cross-hatching. Above them curl banners using words such as 'Blue Chip' and 'Options'. Certain banners read 'Key to the City of Monsters', implying that entry to the City is through knowledge of the language of finance. As the collection was on the City theme the colours were restrained, centering on black, navy, grey and dark brown. The clothing used themes from Edwardian fashion while the idea of women now in powerful places in the City inspired a reference to their brave predecessors in the suffragette movement.

Crewel Monsters featured large-scale monsters drawn in a style usually associated with florals on a ground patterned with a tree of eyes. The eyes suggest the easy access to information in today's business world, and the feeling of everything being visible. The fabric was hand-embroidered using traditional chain stitch in India.

In *Bulls and Bears* two creatures express a confident (bullish) or cautious (bearish) approach to the market. The Bull is saying 'Buy old thing' and the bear replying 'Sell old stick'. It became quite popular with the gentlemen of the City, when made up into striped cotton boxer shorts. We also used it for night shirts and pyjamas, traditional shirts and round collared, Edwardian shirts.

The *Money Stripe* design is a simple way of updating the chalk stripe, that most ubiquitous city cloth. The design featured the £ and the $ signs, although if I had known more about finance I would have included the yen and the Deutschmark.

following page
Bulls and Bears
Designed 1987
36 inch habotai silk
and striped cotton
poplin, one colour,
four colourways,
repeat size
20 x 10 cm.

Money Stripe
Designed 1987
36 inch worsted and
60 inch cotton jersey,
one colour, three
colourways, pigment
dyes, repeat size
12.5 x 6 cm.

Banknotes
Designed 1987
36 inch silk twill,
three colours, three
colourways, acid
dyes, repeat size
70 x 90 cm.

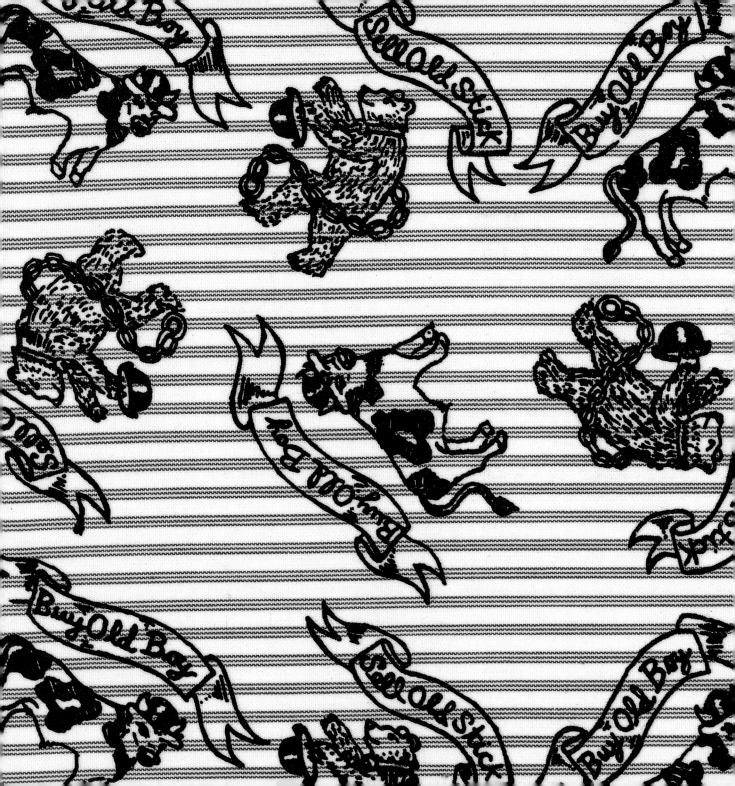

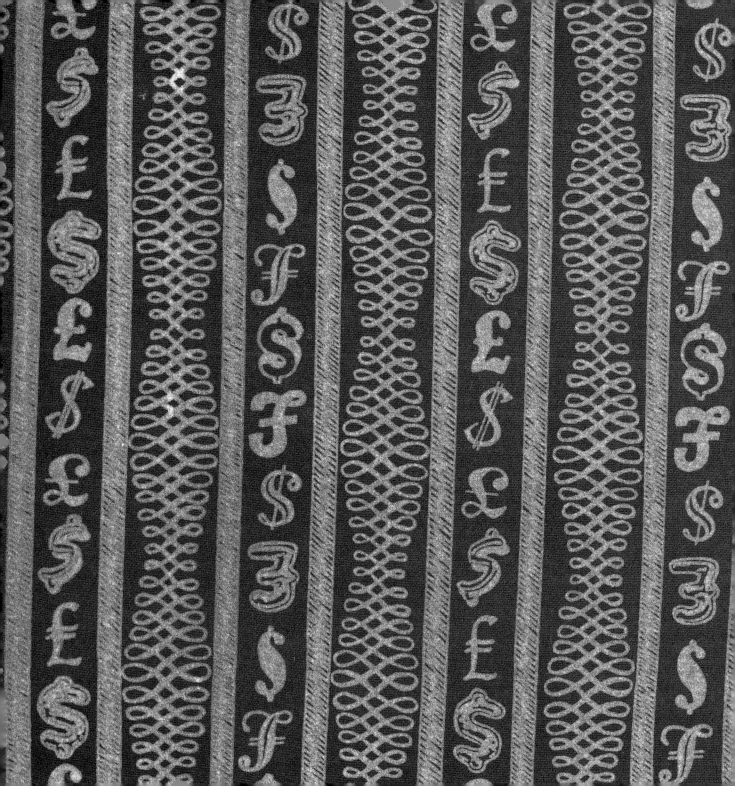

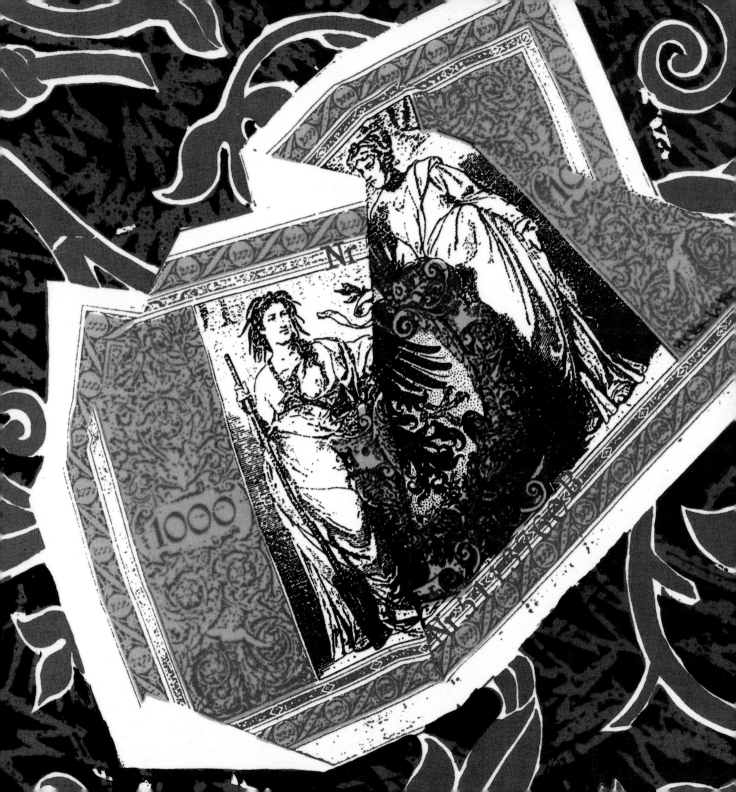

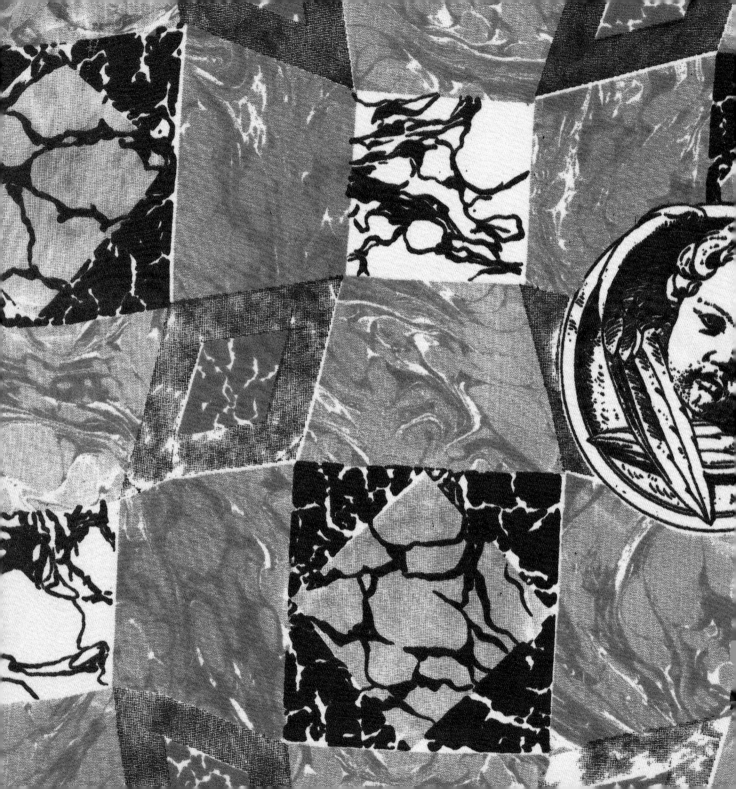

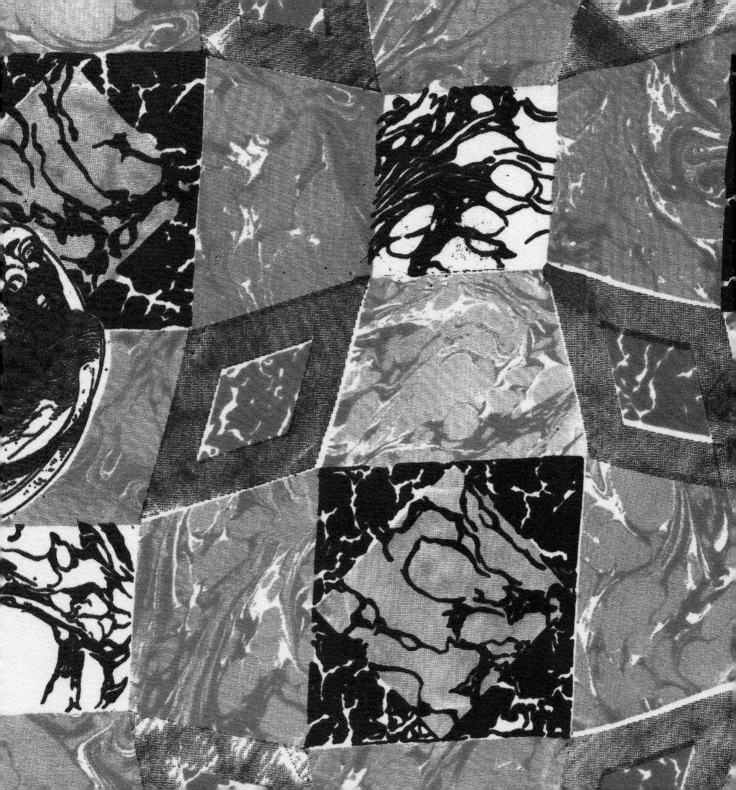

previous pages
Cupid and Marble
Designed 1987
45 inch crepe de
chine, two colours,
four colourways,
acid dyes, repeat
size 45 x 90 cm.

Heads and Diamonds
Designed 1987
45 inch crepe de
chine, two colours,
four colourways,
acid dyes, repeat
size 10 x 7.5 cm.

The quiet, tonal colourways, pale blue on navy and black on flannel grey, were used to suggest a woven rather than printed cloth. This printed worsted was used for women's and men's suits, all with high break-points continuing the Edwardian styling of the whole collection.

In *Banknotes* the notes used are pre-revolutionary Russian roubles, brought into England by a member of my husband's family. My interest in the use of banknotes was aroused by seeing the work of the artist J.S.G. Boggs who draws and paints them. He also uses his drawings in lieu of real money when he wishes to and finds the public are happy to accept a drawn note. When these works of art have been 'spent' they go up in value. As our decorative old roubles were no longer legal tender, it was possible to use them in my design without running into any legal problems. I photocopied them and then folded the copies to imply a three-dimensionality. The notes are strewn over a ground patterned with a stylized vine, on a wax-resist texture. The idea of actually wearing money reflected some of the priorities established by 1980s political life. However, reference to the old Russian dynasty introduces a touch of irony.

Cupid and Marble is a design that was shown alongside the *City of Monsters* collection for menswear accessories. I used inter-cut mechanical and hand-painted textures to create a marble-like surface reminiscent of the grand modern architecture in the City. The carved cupids' heads reflect the decorative detailing on the more ornate 19th century buildings. Designed with the menswear accessory market in mind, its colourways were fairly restrained, using greys, browns and navys.

Heads and Diamonds was also designed as a menswear print and its small scale made it particularly suitable for ties. As in *Cupid and Marble*, an antique image, this time the head of Michelangelo's David, is combined with an architectural background using the black and white marble floors of neo-classical hallways.

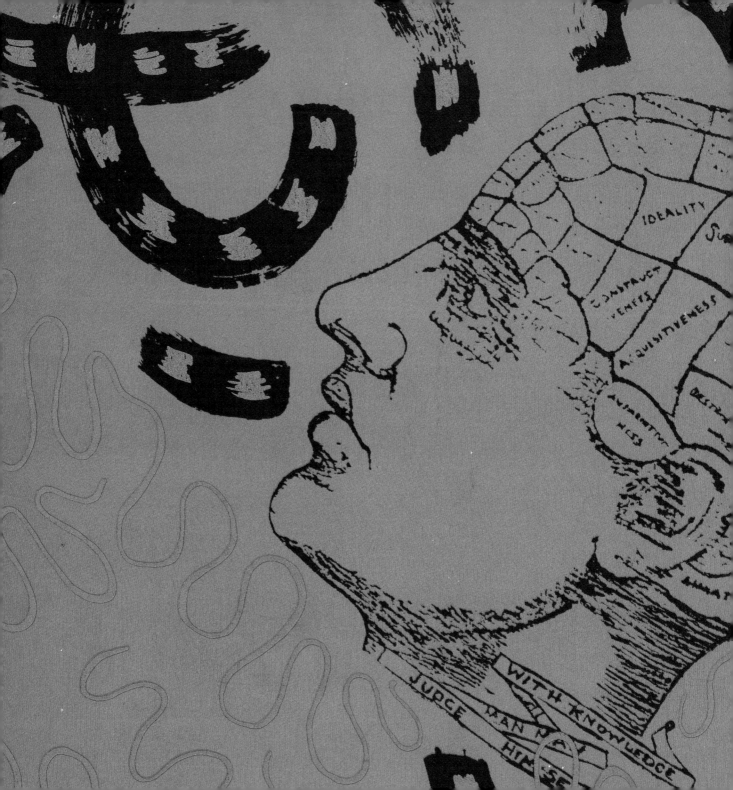

'My mind to me a kingdom is

Such present joys therein I find

That it excels all other bliss

That earth affords or grows by kind.'

Sir Edward Dyer

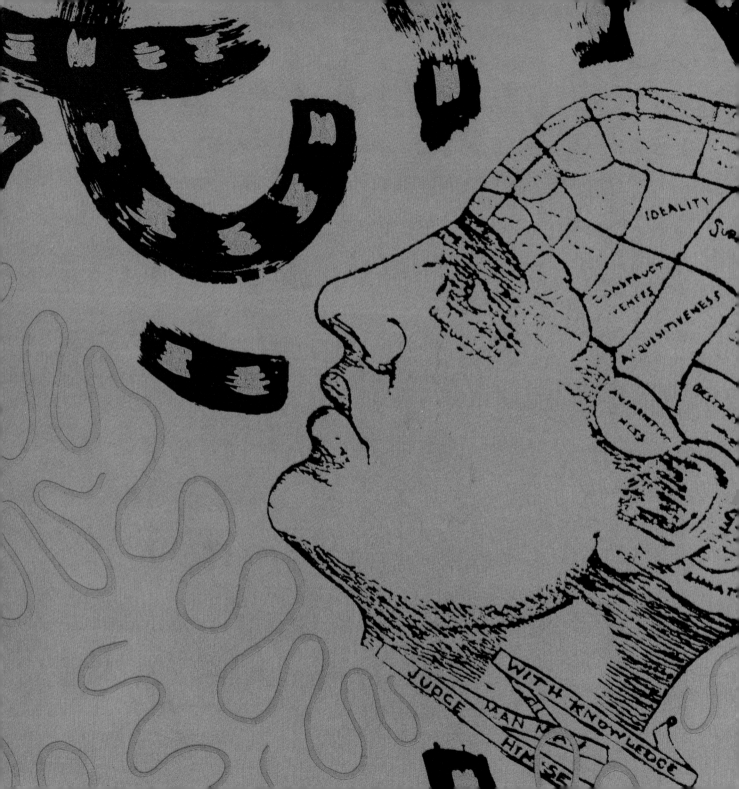

Freudian Slips

The mind … now that is a place you can't always get to, and even if you do, it's so easy to get lost there. The mind is a subway line not often used by mainstream fashion people. They prefer to travel on a less complicated line. Maybe its the Circle Line, which has four seasonal stops: autumn (paisleys and tweeds), winter (tartans and Christmas glitz), spring (pastel colours and pretty florals), and summer (jungle brights and sailor stripes). It goes round and round again. Sometimes a strike on the line will force fashion manufacturers to use another one.

In the early 1980s everyone wore BLACK and only black. The device of creating colour changes every season, to force people to buy a new wardrobe, failed miserably. Once people had purchased their *de rigeur* black outfit, how could they be persuaded to buy more?

As I write, an enormous outside pressure is making the fashion industry use the green line. Green tickets are now accepted for use in any area of the fashion business. Every station now shows designs incorporating leaves, fake fur and the colour green. This ecologically-inspired sartorial journey, albeit a quick dash through Regent's Park to the Zoo, is a welcome relief from the monotony of predictable predictions.

The mind … now there's a place you can travel around for free, but once inside this maze, you will probably get lost. There are huge clumps of ideas, not only one's own, but other people's too, there are tangled up emotions, unreliable memories, and the huge boggy area called 'Belief'. E.M. Forster did not believe in belief. I am unsure whether I believe in belief, but I do know that it fascinates me.

The mind-inspired designs in this chapter may be concerned with scientific ideas or belief-based ideas: the common factor is that they are ideas about ourselves. For me there is no chasm between science and belief. Today's science is tomorrow's old wives' tale. It only takes a Copernicus to push the old science of Astrology from its throne in the palace of scientific truth to the murky abyss of old beliefs, and to replace

Heads
Designed 1984
36 inch habotai silk,
two colours, three
colourways, pigment
dyes, repeat size
60 x 90 cm.

it with the new truth called Astronomy.

Why should a fashion/textiles person be concerned with ideas?

The way we dress in the advanced countries of the world is no longer just about covering our bodies in materials of a suitable weight. Neither is it such a reliable indicator of our financial situation or even of our sex as it once was. Fashion in the 1990s can not be dictatorial. It is no longer able to sell us new clothes every six months by forcing silhouette and colour changes.

Fashion must be a wearable barometer showing the psychological climate of the world. The designer's problem is that ideas are abstract things and designs are visual, tangible things. One needs to find the physical aspects of an idea, to study the time and place where it exists.

Sometimes it works the other way; a visit to an evocative place can inspire the designer with its ideas. As with scientific research, one should not have a preconceived notion about the results of such an experiment, but should let the place tell its own story.

Hands was inspired by my first trip to New York. Expecting to walk into a 1940s musical, I was slightly disappointed with the lack of glamour in most areas. The dress sense was extraordinary: people looked like the kind of playing cards where you match the top half of a person to their bottom half, only most of them had been mismatched. Women with pussy bow ties and neat little jackets on top had clumsy great track shoes on their feet.

The best things were the 24 hour availability of coffee and cheesecake, the insane taxi drivers, and the grafitti, hated by most New Yorkers. The energy and colour of grafitti suggested the optimism, rather than the dissatisfaction of the urban poor. The gestural quality of the marks and the obvious speed with which they had been made related to modern American art. I discovered the work of Keith Haring and enjoyed his fast pattern-making and his desire to smother a surface with marks.

ESP
Designed 1983
60 inch cotton jersey,
one colour, two
colourways,
fluorescent pigment
dyes, all-over and
placement print,
repeat size
38 x 46 cm.

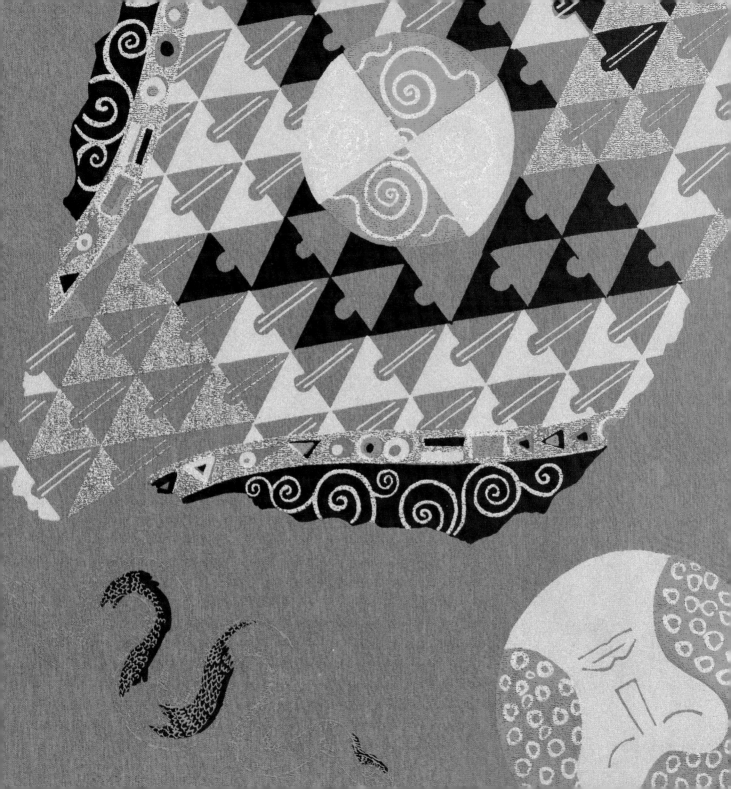

Klimt
Designed 1986
60 inch cotton jersey,
four colours, five
colourways, pigment
dyes with metallics,
repeat size
74 x 76 cm.

A surprise was the frequent appearance of palmistry parlours all over Manhattan. For me palmistry has the air of Brighton Pier, and seemed out of place in such an advanced and powerful city. It could be that the cultural mix of New York makes it a place where people are more likely to believe in occult systems, or that so many people have come there to fulfil a dream and need reassurance that the dream is still within reach.

These New York elements of grafitti marks, spirals and palmistry diagrams, were the basis for the *Hands* print. Initially in the preparatory sketches, I used my own hand-print, but I preferred the linear qualities of the diagram used in the final design. In my work the spiral is a symbol of life; in this design the spiral pattern is based on Gustav Klimt's 'Tree of Life'.

Hands has been re-scaled for use as wrapping paper and reinterpreted as a hosiery design. It has developed into English Eccentrics' best-known design.

Heads was designed as a companion piece to *Hands* using a similar pattern of distribution and equally diverse subject matter. *Heads* mixes a phrenology diagram with an Indian-inspired border and loose paisley forms. The remaining background is enlivened by a meandering pattern based on an early 1950s tea-set of mine. The colours are bright: hot pink, orange and turquoise. This design was also printed on linen for an International Linen promotion.

ESP was the 'cruise' season's version of a previous collection, *Glam* for autumn 1984. The *Glam* collection was the first created with Judy and Claire. We used small screens with placed images of stars, an all-over tartan printed in Spantex for a three-dimensional effect, and simple bold graphic signs used for testing extra sensory perception. These hard-edged symbols were taken from a psychologist's test for ESP, each image dissimilar to every other to enable (in theory) the thought waves passing from viewer to receiver to remain clear. The test is based on five images printed onto cards being looked at by one person; simultaneously a second person attempts to draw

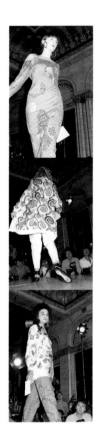

or name them. If the number of correct interpretations is well over the norm expected by chance, it can be argued that the results are due to the presence of ESP.

The basis for the collection was to mix mind-inspired images for a print on body-conscious silhouettes. We chose sportswear fabrics to print on, and Claire created sportswear-based shapes. To suggest a high-tech feeling the colours were fluorescents on white. The images could be printed as an all-over, or used as a placement strip or patch.

English Eccentrics were included in a fashion show in Vienna as a part of a major British design exhibition opened by the Prince and Princess of Wales. Judy and I decided to make this visit the basis for our collection for summer 1987, *Freudian Slips*.

Vienna was an extraordinary place in that it seemed exactly as one would have expected it to be a hundred years ago. Karl Kraus described the town as 'The experimental station for the end of the world'. The highly decorative interiors and elaborate cakes of the coffee-houses, the elegant, bourgeois gardens where people strolled lazily with little dogs, the heavy *fin-de-siècle* architecture all seemed trapped in time.

The decadence of the 1890s still hung in the air, and for us there was the added threat of the lingering anti-Semitism that caused Freud to leave his home town at the age of 81, for London, where he was to die two years later.

Klimt is one of a series of designs inspired by our visit to Vienna. It is a tribute to Gustav Klimt, inspired by his 'Beethoven Frieze' inside Joseph Olbrich's Secession building. Klimt's vision of the subconscious mind, along with his skill as a colourist and pattern-maker means that for me he will always be a favourite painter. The Beethoven frieze depicts the ability of art to help mankind triumph over his sufferings. My design includes patterns based on fragments of this work and two stylized faces found above the heads of the lovers in the final panel of the frieze. To these I added images of a deathshead and a cherub to suggest the extremes of life and death

Mixed media drawing for Freud Designed 1986 36 inch habotai silk, three colours, three colourways, acid dyes, repeat size 71 x 57.5 cm.

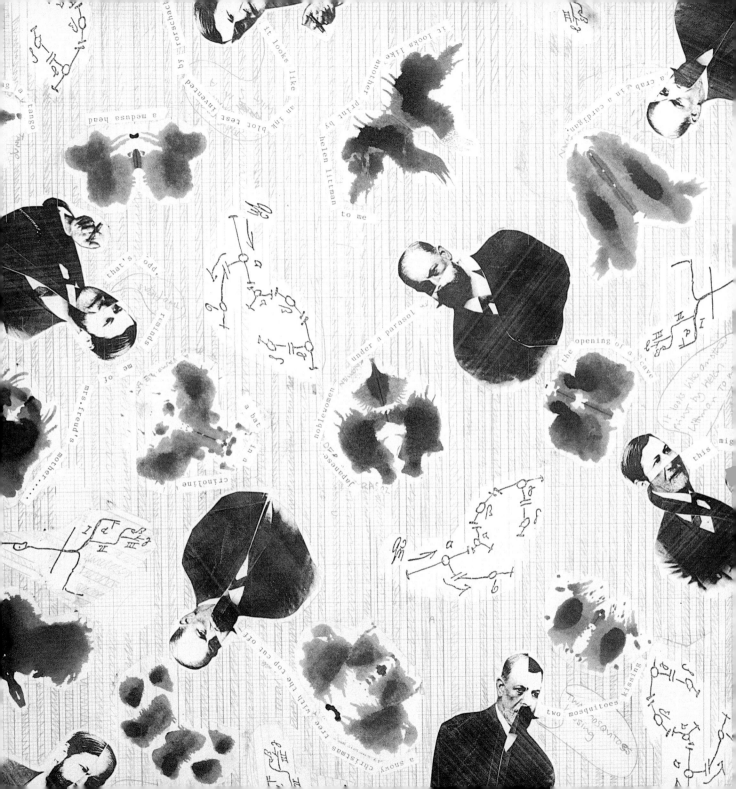

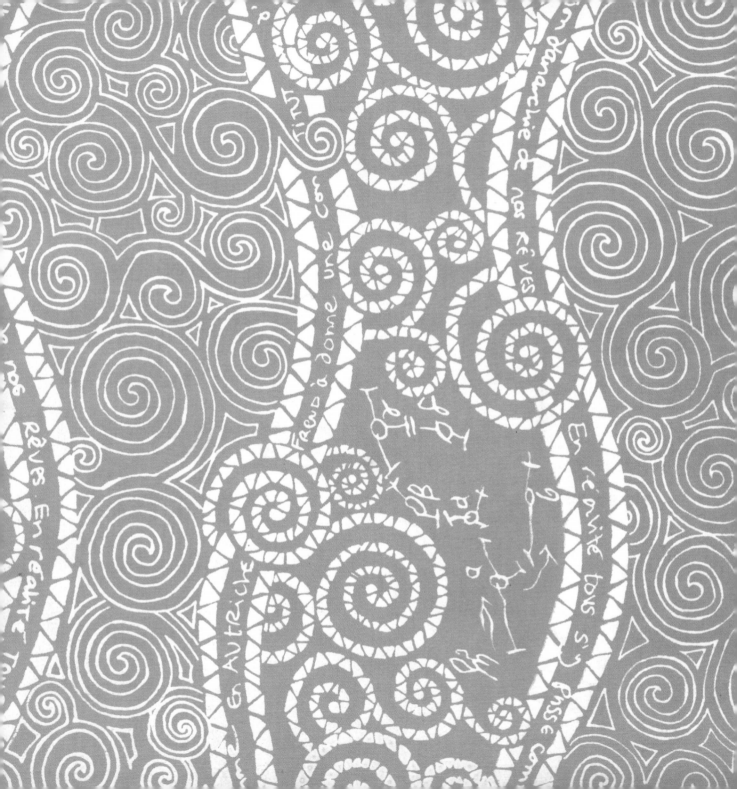

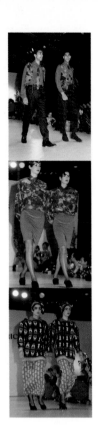

**Brainwaves
Designed 1986
45 inch cotton
poplin, one colour,
three colourways,
pigment dyes, repeat
size 38 x 32 cm.**

**following pages
Dada
Designed 1986
45 inch crepe de
chine, two colours,
six colourways, acid
dyes, repeat size
67 x 110 cm.**

which preoccupied the artists and thinkers of turn-of-the-century Vienna.

There was a fascination with dreams, a disenchantment with Nature, an obsession with the struggle between good and evil, innocence and depravity, that characterized the work of writers, scientists, musicians and artists of that era. The golds, soft yellow, verdigris, rust, eau-de-Nil and lilac in the colourways are based on colour notes taken from Klimt's work.

Freud's surgery was at 19, Berggasse. On our visit we saw the famous room where the feelings and thoughts of the Viennese were revealed to the great man, and many interesting old documents and letters to his famous contemporaries who included Sarah Bernhardt. Freud had indubitably the greatest effect on 20th century thought of any philosopher or scientist, with the possible exception of Einstein. However, after reading books lent to me by Peter Ayton, a lecturer in psychology at the City of London Polytechnic, I realized that Freud's theory of sex role development was unacceptably phallocentric. Freud's study of dreams is probably the best known and most influential of his theories. In *The Interpretation of Dreams* he suggests that children are symbolized in dreams by 'little animals or vermin' and women by 'snails and mussels'. The revision of my perspective on Freud suggested drastic action so I decided to cut up the portrait photographs chosen for use in the design. The *Freud* design also featured Rorshach's random ink-blots devised to test both general personality characteristics and unrevealed conflicts. The text on the print consists of interpretations of various ink-blots shown in the design, provided by the English Eccentrics staff.

Brainwaves is a simple design also based on the work of Freud and Klimt. The brainwaves are suggested by the spiral forms; the diagram is taken from a drawing by Freud to analyse sexual attraction, and the Karl Kraus quote is: '*Freud a donné une constitution d'anarchie de nos rêves. En realité tout s'y passe comme en Autriche*'.

Judy created beautiful Klimt-inspired machine-knits with metallic yarns to compliment the prints and Claire chose silhouettes based partly on Edwardian dress

est mort
est idiot

vive le
vive le

DADO

est mort
est idiot

DADAISMUS

dadaismus hat

as inseparable from the bank-up
confirm the bank-up

coloré l'a
belgique a
Vénus
Laocoon
enfin
pas dans
à son-
milliers
sme la
mög

Indifferenz
Instruktiven
geführt.
eichen,
Nonsun

to
the
and
s" to
st

FIRST-CLASS DESIGN
INGLISH ECCENTRICS

vang erkle
o klstiert
hnen" n
ingkam
nge

BIG LIVELY PRINT

and partly on *Alice's Adventures in Wonderland*. We presented the collection in the Criterion Brasserie, which has a golden mosaic ceiling that had been recently rediscovered under an ugly 1960s false ceiling, and decorative marble walls evocative of *fin-de-siècle* Vienna.

In the winter of 1985 Colin and I went on holiday to Mauritius, an island famous for something that is not there – its extinct bird, the Dodo. During the holiday we were reading books about Surrealism and the Dada movement. I used these two diverse themes for the *Dada* collection. The instigators of Dada, Tristan Zara and André Breton, were young men disillusioned with ideas about nationalism, the glory of war and the thought of dying for one's country. The state made them feel claustrophobic, and their rebellion was against the establishment, which they could not trust, and its manifestations of 'good taste'. In its anti-authoritarianism, the Punk movement of the mid-1970s seemed similar. Back in London, while we were planning our collection for winter 1986, I realized it would be the tenth anniversary of the emergence of the Punk movement and designed the *Dada* print with this in mind.

Against a background of camouflage brushmarks, fragments of poetry in various languages from the Dadaist manifesto are combined with a surrealistic hand and an engraving of a dodo. I used the dodo to symbolize the extinction of all art movements.

Inspired by Peter Greenaway's film *A Zed and Two Noughts*, we presented the catwalk show using twin models. Claire used zips decoratively as her tribute to Punk, and the colour shocking pink, invented by the most surrealistic of fashion designers, Schiaparelli. Hats were bamboo bird cages, as used by André Masson, in his *Mannequin with Birdcage* for the Exposition Internationale de Surrealisme of 1938. Judy's machine-made knitwear was a *trompe-l'oeil* Fairisle which in fact featured ants and mannequins in its pattern. Colours were Punk's black, red and shocking pink, and a military-camouflage beige and brown.

Hands
Designed 1984
36 inch and 45 inch
habotai silk, two
colours, five
colourways, original
print in pigments,
reprinted in
discharge and acid
dyes, repeat size
64 x 114 cm.

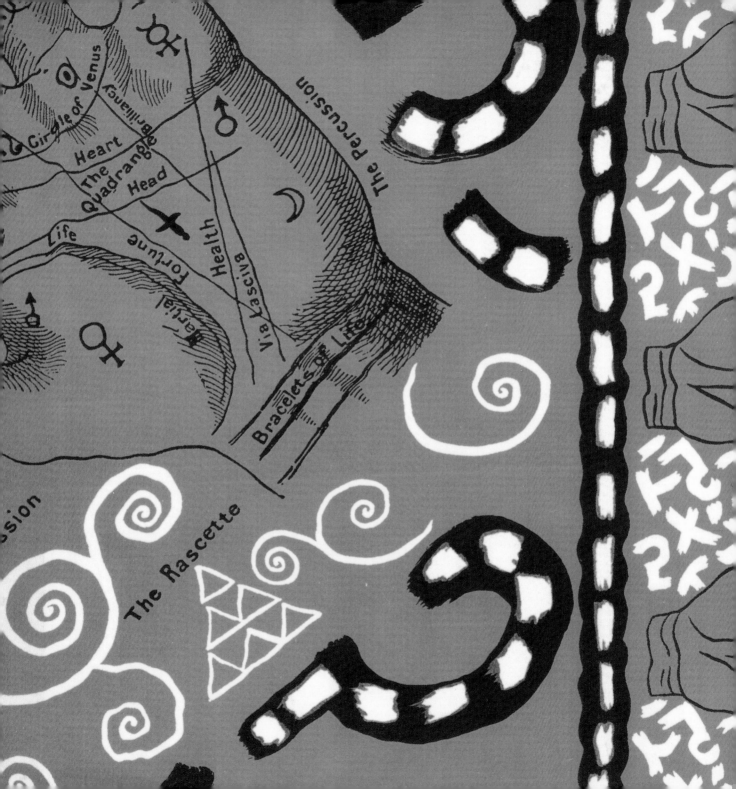

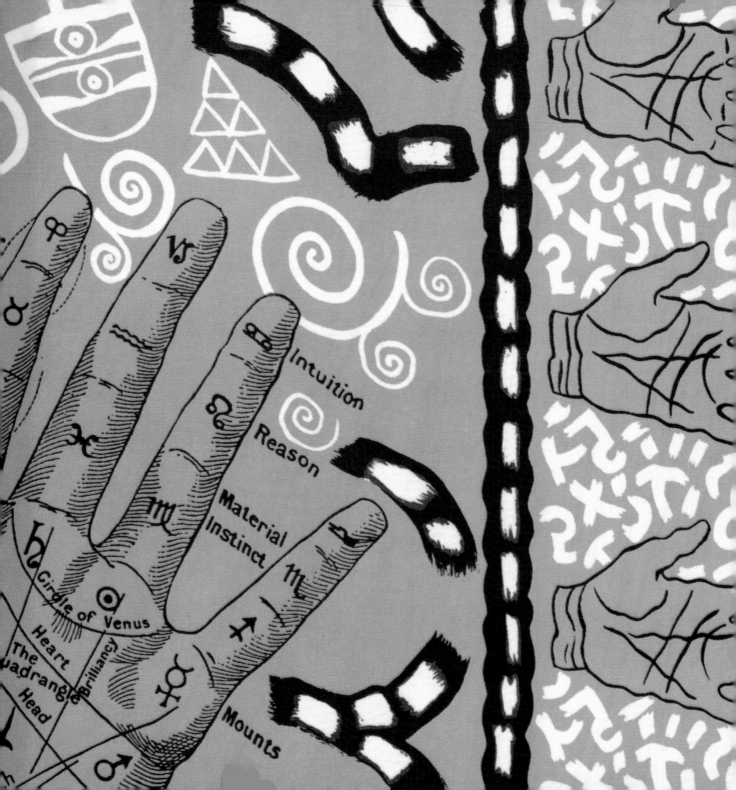

Intuition

Reason

Material
Instinct

Circle of Venus

Heart

The
Quadrangle

Head

Brilliancy

Mounts

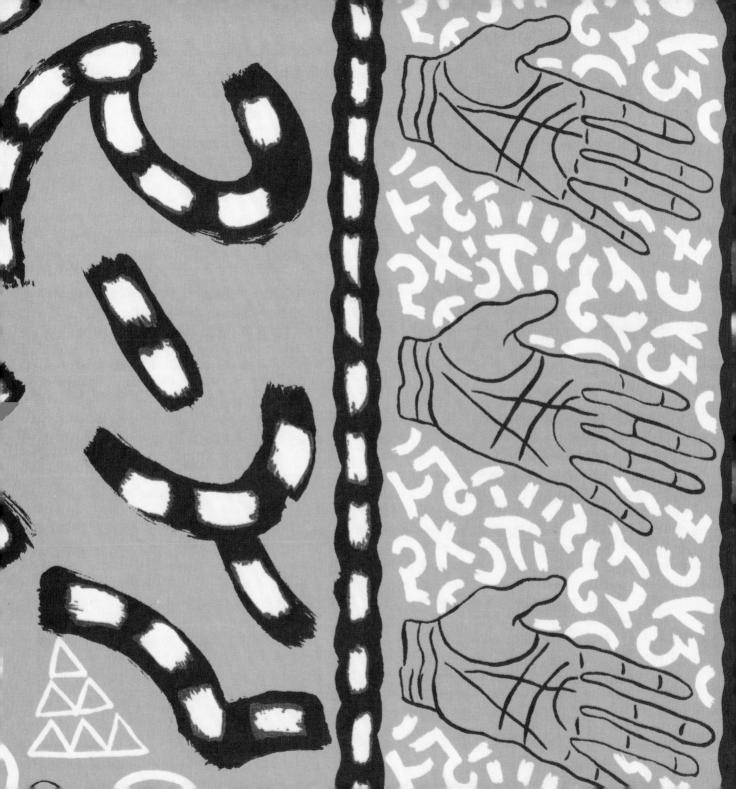

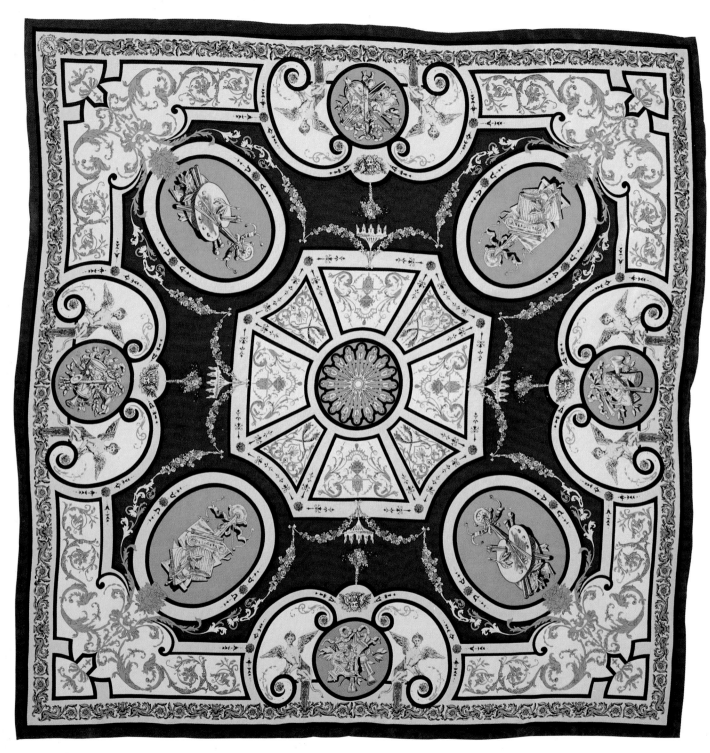

Attributes
Designed 1989
45 inch crepe de
chine, five colours,
three colourways,
acid dyes, scarf
format.

following pages
Faces
Designed 1987
60 inch cotton
pigment print, one
colour, repeat size
94 x 120 cm.

The *Attributes* scarf celebrates the 18th century accomplishments of architecture, music and fine art. The structure is based on a French 19th century ceiling. The large ovals in the middle of each corner show the attributes of architecture or fine art. These are drawn in a style based on diagrams intended for carpenters and plasterers. The four rondels at the centre of each side of the scarf show different musical instruments with leaves and bows. Beside each rondel are sphinxes, the guardians of the soul's secrets, who understand the mystery of creative talent. Each area of the pattern is separated by a thick black border which imposes a formality on the whole. To lighten this effect, garlands and arabesques connect the centre of the design to the edges. The outer border shows stylized dolphins, flowers and lyres.

Astrology is the study of the cosmic forces of the stars in our galaxy and their bearing on humanity. It developed from centuries of sky-watching until it was realized that the sun's journey through the sky took it past what appeared to be particular constellations at certain times of year. These constellations suggested various images, and different cultures developed their own star signs and ruling gods and goddesses, but eventually the number of signs was fixed at twelve.

Astrology also links up with other belief systems: the Medieval idea of the four humours – sanguine, phlegmatic, melancholic and choleric, each one governed by one of the four elements; the Tarot system where each major arcana card has a corresponding star sign, and palmistry in which each area of the hand has a governing planet. A basic model of atomic particles moving around a neutron is so similar to a model for the galaxy with planets moving around the sun, that one can see the attraction of the macrocosm/microcosm vision provided by astrology. Historically comets and eclipses have always been seen as signs of momentous events. Even today we discover that world leaders – for example the Reagans – are influenced by astrologers, just as the Roman emperors were. Star signs are a subject which many people feel very strong sympathy or antipathy towards. My own interest in astrology is like my

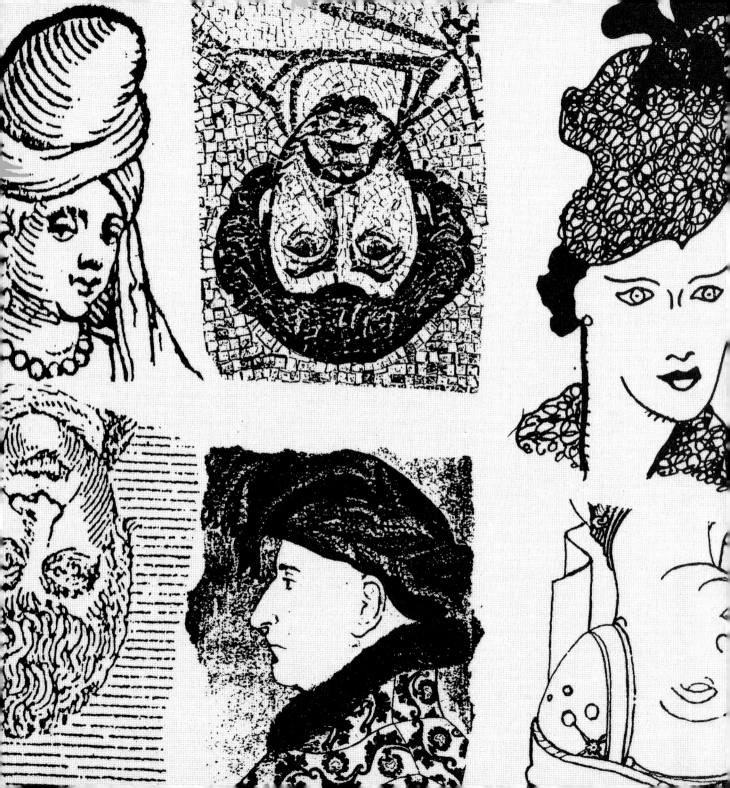

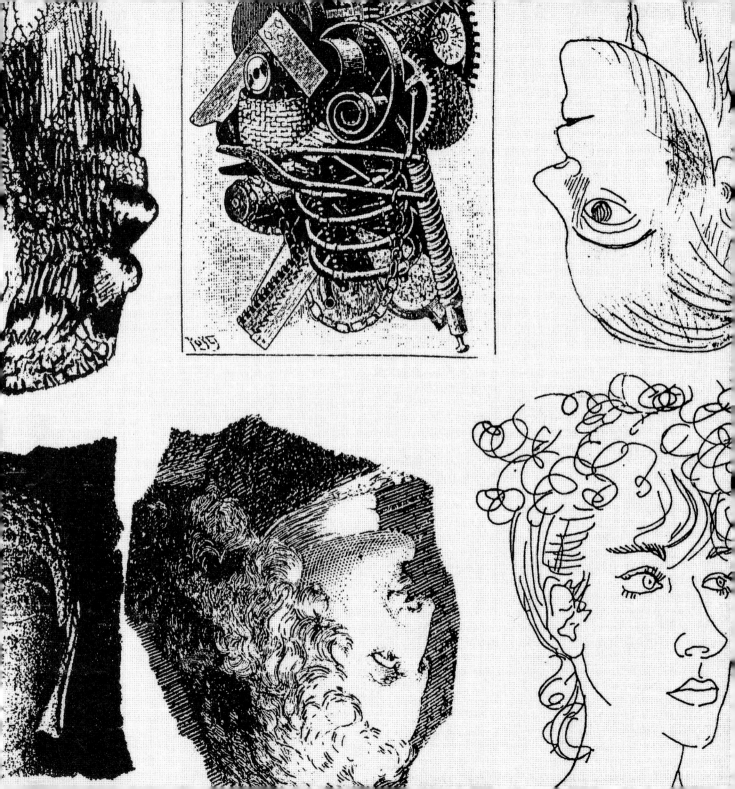

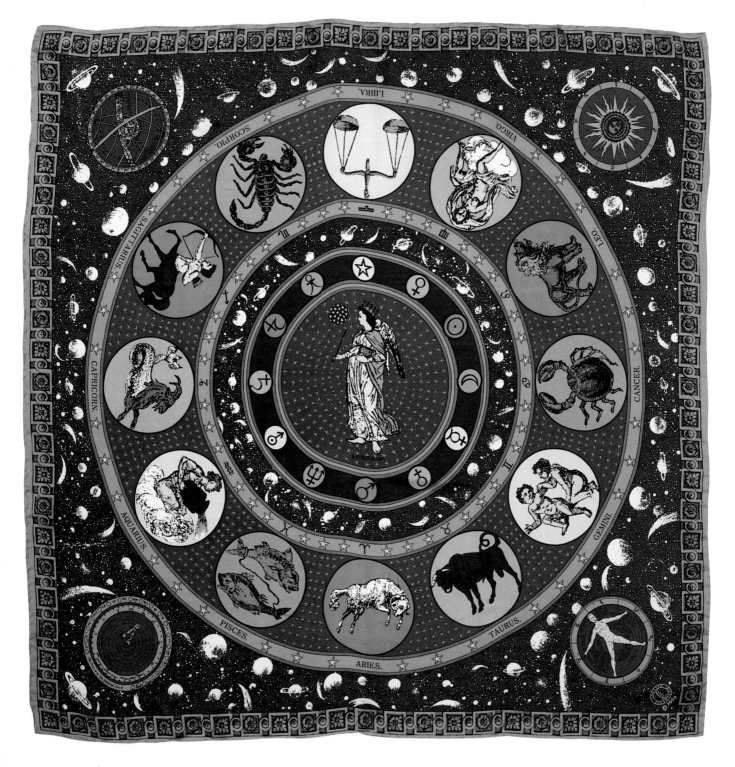

interest in all belief systems, mainly visual. I find the symbols for each sign graphically pleasing and the different styles in which the signs have been represented over the centuries are fascinating.

The *Astrology* print depicts the twelve signs in their traditional order contained within a starry band surrounding the muse 'Astrologia'. Inside this an inner circle shows the symbols for every sign. Each sign is drawn within a circle where its corresponding element is indicated by the background colour. Beyond the signs the design is of planets and stars in the universe, and the border is a gold band with a pattern from the renaissance period.

The design of *Faces* was inspired by our visit to the *Arcimboldo Effect* exhibition in Venice, 1987. The exhibition presented the master's work as the first surrealist paintings, and went on to show later surrealist tendencies in fine art up to the present day.

Faces explores the changing perception of the human face over the centuries from archaic to modern times. Some faces are by Arcimboldo and his followers using the famous composite images he invented. *Faces* explores different views of beauty and different methods of representation, from mosaics and frescoes to Picasso-inspired heads. Judy redrew many of the faces used in this design, and added line-drawings she made of herself, Claire and me.

As an all-over design *Faces* was used for cotton separates and later at a reduced scale for stationery. I carried the theme on into two co-ordinating placement prints for T-shirts: men's faces and women's faces.

Astrology
Designed 1989
36 inch silk twill,
eleven colours, three
colourways, acid
dyes, scarf format.

'The power who exists in all beings

as peace, reverence to her,

reverence to her, reverence to her,

reverence, reverence.'

From the *Devi Mahatmya* (a hymn to Kali)

Peace Angels

What are we? Women of the 1990s. Workers, mothers, peace-bringers. How have we been shaped by recent history? Do we yield more power now than we have done in the past?

My view of modern women encompasses both their life-giving, life-protecting potential and their capacity for intuitive thought. If we have gained any power this century it seems that now is the time to use it.

History has been written and dominated by men. The world has always been seen as a man's world. Men have strived to develop faster means of transport and communication, to conquer the elements and to build ever larger cities with ever taller buildings. Men tend to compete, women to co-operate. When men's territory is threatened, they create wars. 'What is the arms race and the cold war but the continuation of male competitiveness and aggression into the inhuman sphere of computer-run institutions?' asked Germaine Greer in *The Female Eunuch*. Twenty years after this important book was published, these thoughts are nothing new. What is new is a universal realization that the world has reached a critical stage, that the way we have been going may have literally cost us the earth.

Greenpeace makes the point with a dramatic comparison. If the earth is 46 years old, then the industrial revolution took place in a minute. Mayhem in one minute.

Writers, philosophers and activists all over the world have responded to this crisis, talking about the need to consider our planet as a living organism. One example comes from scientist Jim Lovelock's revival of the Gaia theory. This ancient concept of Mother Earth suggests that the world needs to be loved with a woman's respect for life and for nature.

Science has dominated in the recent development of the world, but its discoveries and theories have no moral context, being justified by empiricism and logic. Even great women philosophers such as Simone de Beauvoir placed logical thought above

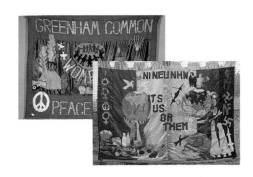

intuitive thought. In *The Second Sex* she argues that 'Women's mentality perpetuates that of agricultural civilizations which worshipped the magic powers of the land'. She goes on to suggest that woman is 'not familiar with the use of masculine logic' and that this is the cause of her weakness. Intuitive thought has always played a minor role, the term 'female intuition' is often used in a derogatory manner, and its low esteem has encouraged a dangerously one-sided development.

Scientists are now confounded by phenomena which may be empirically proven but which by their very nature disprove the validity of logic as a complete system. One example is Rupert Shelldrake's theory of morphic resonance which would seem to strengthen the argument for a collective unconscious by showing that as soon as any idea exists in the world, there is an increased familiarity with the idea everywhere.

The terms male and female represent a dualism that is perceived in all cultures. Logical and intuitive thought are sometimes termed 'right brain and left brain'. For Freud the love of life and the deathwish are represented by Eros and Thanatos. In Eastern religions there has always been a respect for the balance between the destructive and the creative, Yin and Yang. In the West that balance has been lost under the pressure of a particular definition of progress. Until now the male side has reigned supreme. Yet in many cases it is women who have alerted world attention to problems threatening our collective future. In Greenham women camped for peace, in India they hugged trees against developers, in the USA they formed pressure groups to ban dangerous agricultural chemicals. Women are proving themselves to be the guardians of life on this planet.

Being a woman is crucial to my work. I like the company of women and all the full-time staff at English Eccentrics are women. As a designer, my preferred perception of the feminine image is very definite. Ideas about the female experience are reflected in designs such as *Peace, Angels, Ceres,* whereas *Ocean, Gaia* and *Medusa* reflect

**Peace Women
Designed 1985
45 inch crepe de
chine, two colours,
three colourways,
acid dyes, scarf
format.**

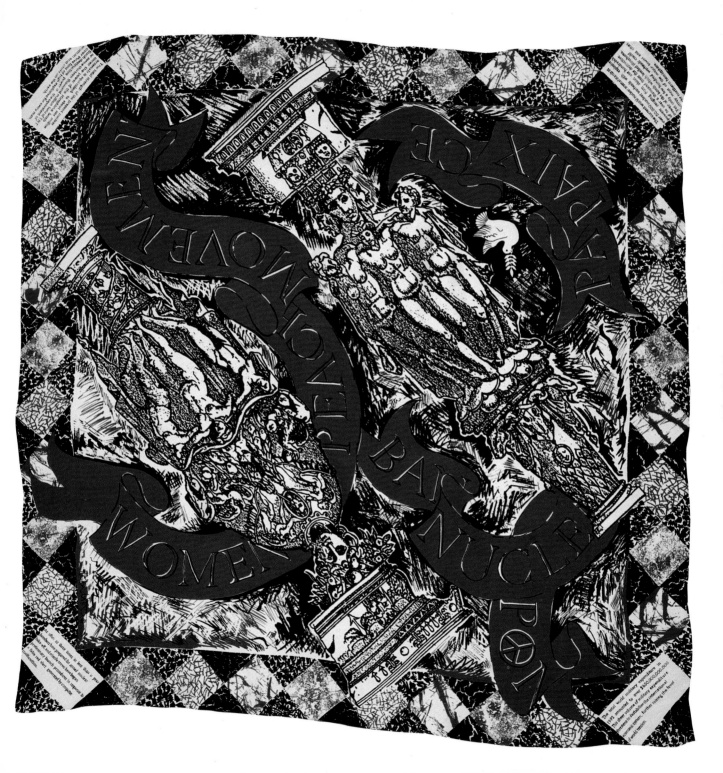

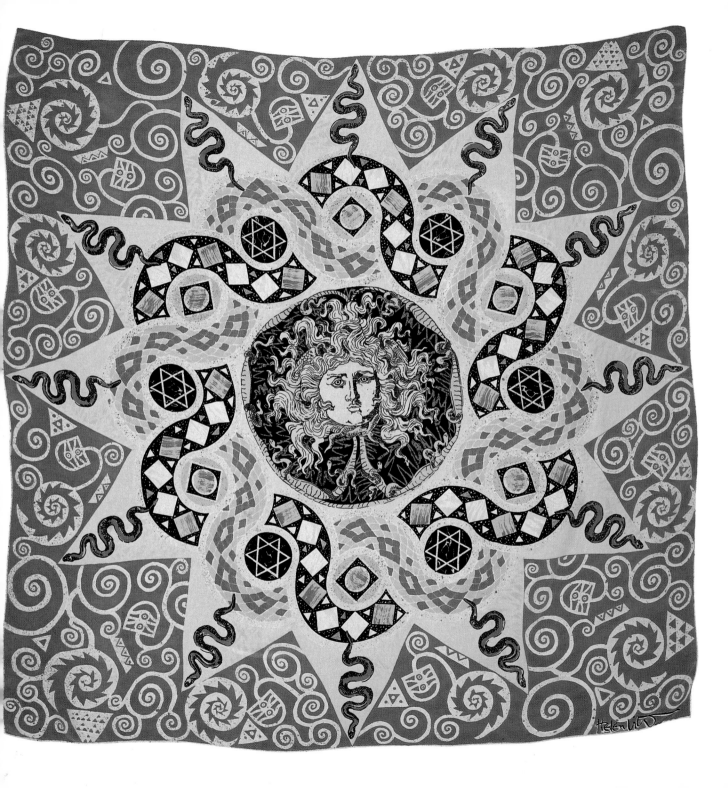

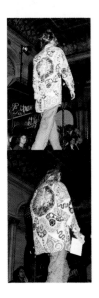

the feminine principle. I believe that all women have their own beauty and that striving to look like the stereotyped images in our media can undermine this. However, I feel that there is no reason why we should not enjoy using beauty products and I think dressing well is a great pleasure. For me, make-up or high heels are not undesirable *a priori*, but I don't like to produce obviously sexually provocative clothes because I think that in most social situations they make women feel uncomfortable and look frivolous.

We dress to enhance our appearance, and my aim in designing is that the clothes and accessories we produce are fun to wear and help to make any woman look wonderful be she overweight, over-eighty or a fashion model.

I am always conscious of the body as the final show-place for my designs. An awareness of our recent fashion history is an ever-present factor in the mind of a female designer, and although nostalgic looks are often in fashion, I try to create a style pertinent to our own era. An understanding of fashion over the last century informs the work we are producing today. The ever-changing image of women has speeded up this century, and we have forced our bodies into all sorts of improbable shapes. However, recently this relentless obsession with our image has been turned on its head by the feminists who have made an enormous contribution to our self-esteem. They have encouraged us to look at ourselves clearly as people, not just as objects for men, in an unspoken 'Miss World' competition. They have encouraged us to regard each other as sisters and not as competitors.

A brief survey of womenswear over the century indicates how significant these changes in our self-image have been.

During the First World War, women had tasted their freedom, and in 1928 won the right to vote. They aspired to the new modernism of the 20th century. New architecture, new cars, new women. The ideal look was boyish, with cropped hair and a flat chest. Taking their role-models from women's magazines and films, 1930s women aspired to be perfect housewives, until war broke out, then day-time dress was

Utility, with overalls and turbans.

Glamour was the obsession of the post-War period. Dior's New Look plunged hemlines downward and waists inwards, then in the 1950s rock and roll arrived and circular skirts flared out over legs that finished in girlish bobby socks. Girlish then shifted to childish in the 1960s with Twiggy as the role model for this woman-child; thinness was now taken to an extreme. The hemline was higher than ever before. England in the early 1970s had a retro fashion look with thick platform shoes and tight 'tank tops'. Pop star glam-rock contrasted with high unemployment and economic disaster. The country suffered under a dead-end feeling out of which Punk was born. The most radical of a series of youth-cult tribal fashions, Punk was a period when it was sexy to look ugly. Vivienne Westwood and Malcolm McLaren created this anarchic look as a visual equivalent to the music of the Sex Pistols. Radical chic was an extension of the Punk look: clothes were suddenly practical, allowing women to run around, play with their children or go on protest marches. Katherine Hamnett made this style her own, basing a collection on army surplus clothing.

In the early 1980s the New Romantics took the look of the 18th century Dandy while another style was based on hobos – falling-down leggings, layers of clothing sometimes knotted or slashed, matted hair and dreadlocks.

Late-1980s women experimented with 'power-dressing' – a concept that was interesting because it allowed a woman to look 'feminine' without, theoretically, undermining her ability to wield power and to earn large amounts of money. In 1987 the stock market crash shook everyone's confidence in the City. High finance became synonymous with an unacceptable greed which was damaging the world. The idea of disposable designer fashion is no longer acceptable. As a reflection of the interest in recycling and keeping goods for longer, women in the 1990s are looking for a permanence in the goods that they buy. The craft aspect of merchandise is increasingly important. The idea is that things should be made to last.

Angels
Designed 1988
45 inch crepe de
chine, five colours,
three colourways,
acid dyes, scarf
format.

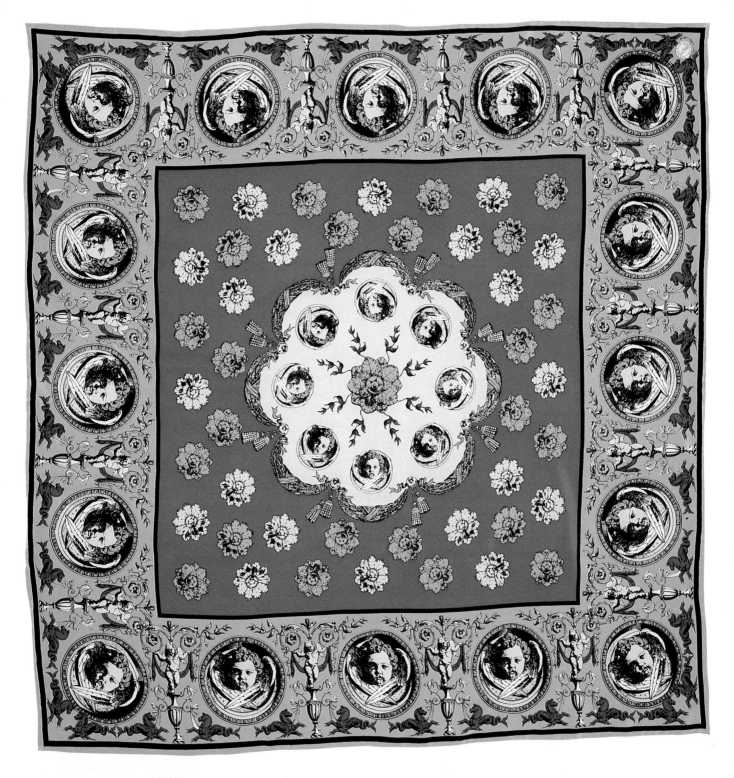

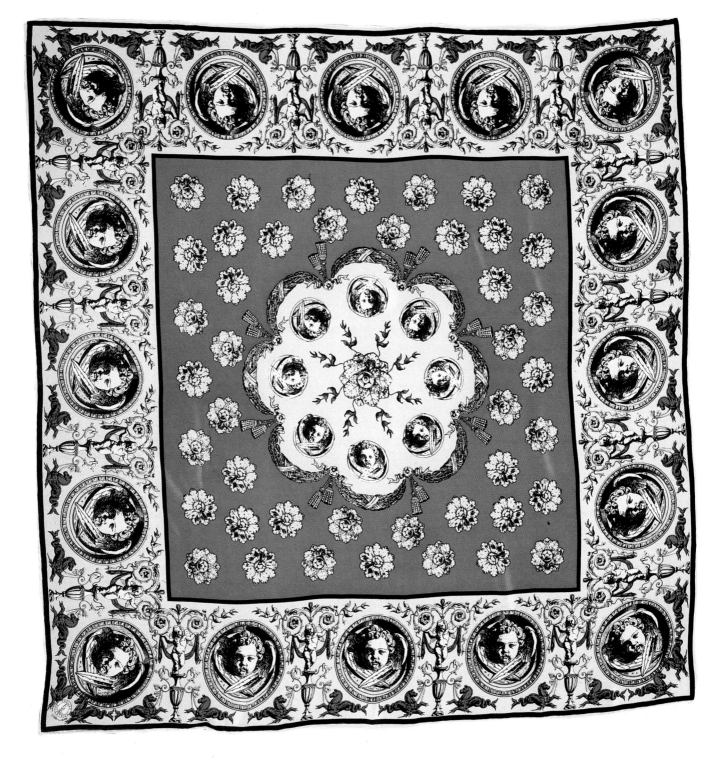

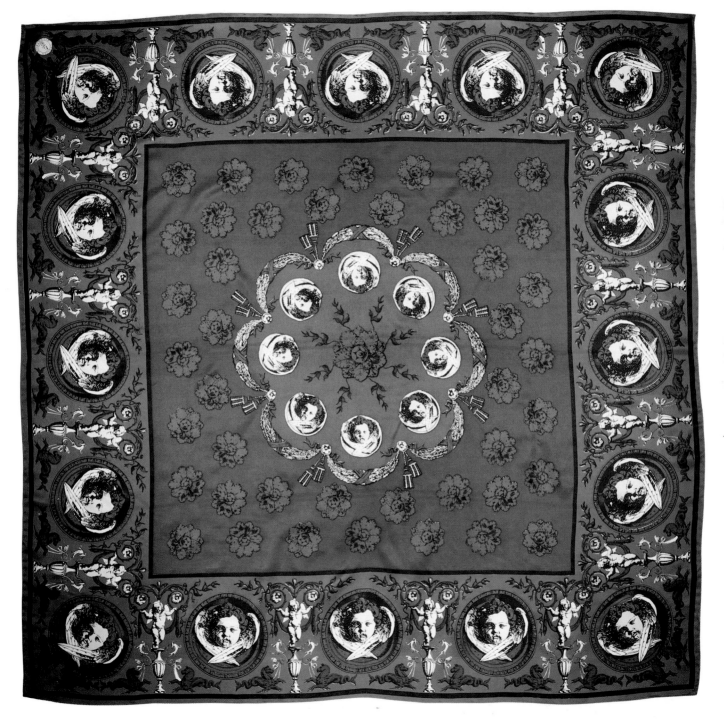

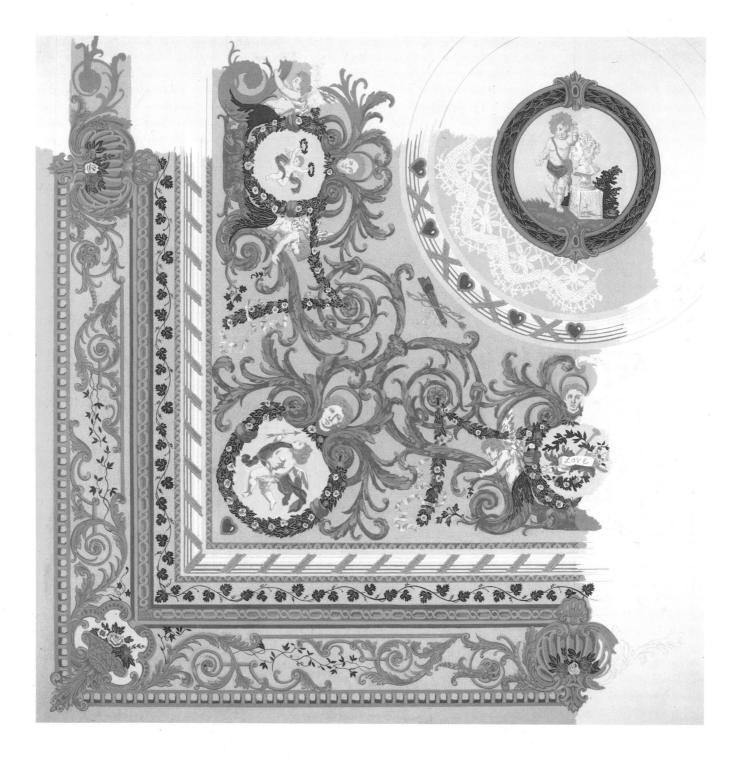

**Gouache painting for
Love, 1989
Designed 1989
36 inch silk twill,
eleven colours, three
colourways, acid
dyes, scarf format.**

**following pages
Ceres
Designed 1989
45 inch crepe de
chine, six colours,
three colourways,
acid dyes, scarf
format.**

This new spirit of strength and permanence is celebrated by the designs in this section. They are in praise of women and a gesture to the future.

The *Peace Women* scarf was inspired by our visit to the women's camp at Greenham Common where a small but determined group of women attracted international media attention. Judy and I visited the camp on a special day in 1983 when mirrors were used to reflect the ugliness of the air base to its personnel. The Greenham women had to face the hostility of local people who seemed to accept that their common land was requisitioned by the MOD and given over to the US airforce. The bravery and determination of these women was very moving. I designed the scarf to celebrate their spirit. The scarf contains three banners: on one is written 'Women's Peace Movement', another says 'Ban nuclear weapons' and the third, 'Pax, Peace, Paix'. Two large renaissance statues dominate the central area of the scarf. They contain images of birds, fruit and women, possibly the three graces. A stylized dove and the CND logo also feature in the centre. The background is textured with brushmarks and wax crayons. The border is made up of cut textures, some mechanical, most hand-drawn. In each corner is a section of text relating to the arms race.

The *Medusa* scarf shows the powerful aspect of woman, as seen by the ancient Greeks. Medusa turned men to stone, and symbolized the fear of castration. Both Klimt and Freud were fascinated by the Medusa myth, and the design developed from my research for the *Freudian Slips* collection. The Medusa head is placed in a wax-resist textured circle, surrounded by snakes. Around this central image there is a pattern of cut stonework that I saw in St Mark's in Venice. Alternating with the stonework is a pattern of snakeskin. Outside this area is a twelve-point star with a snake in each point. There is no formal border, but a Klimt-based pattern surrounds the star extending to the edge of the scarf.

The *Angels* scarf has a much softer feeling than the previous designs. I designed it when I was pregnant, and obsessed with images of *putti*. The main central

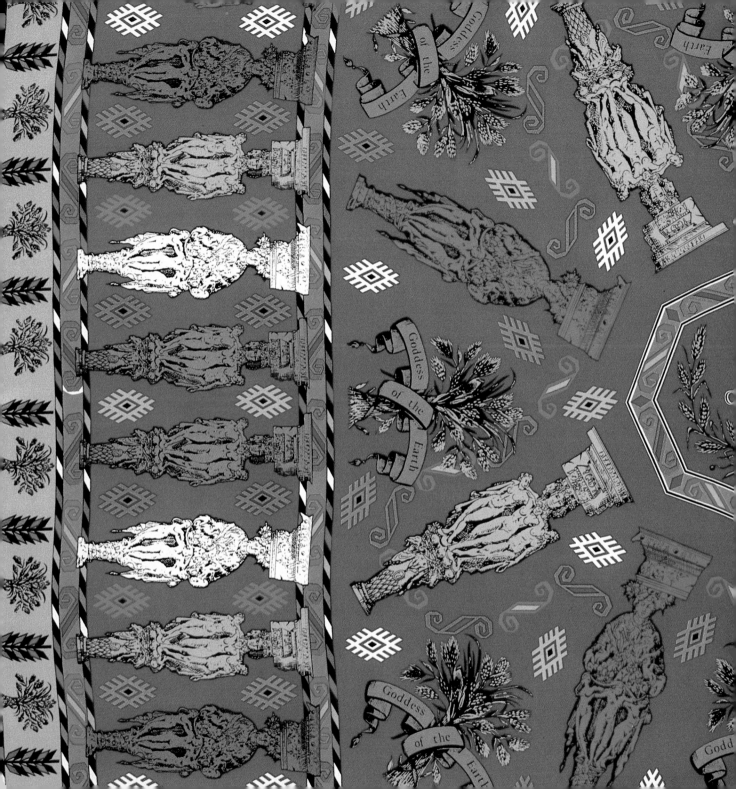

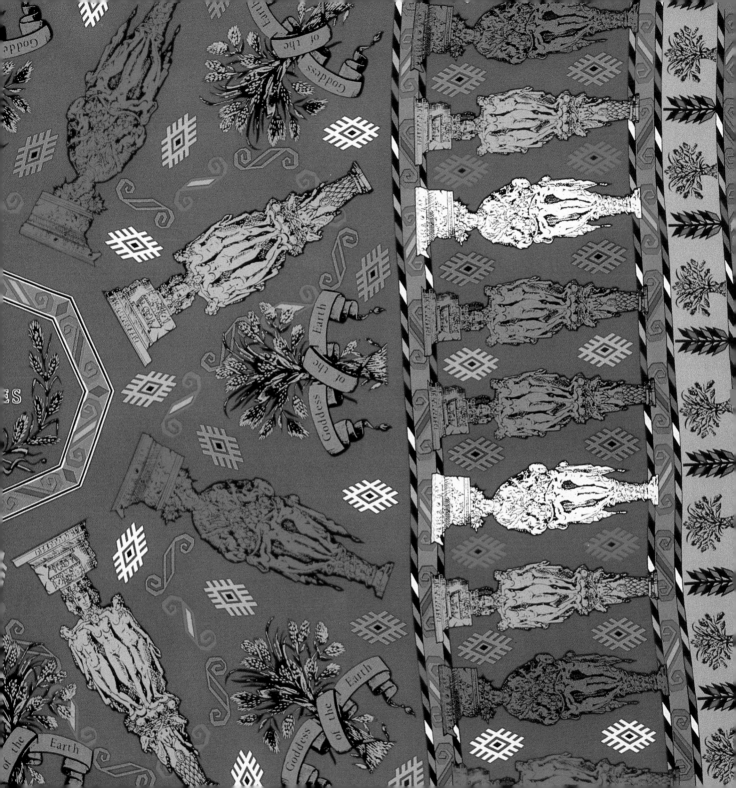

images are angels' heads, garlands and rosettes; rather than being like decorative paintings, they all have the quality of being carved from stone. The border is deep with larger angel heads, seahorses and *putti* on vases. The grey colourway is very calm, the navy and burgundy has a dark wintery look, and the rose and eau-de-Nil is based on the richness of Aubusson carpets.

Ceres is the first design I worked on after the birth of my son, Oliver. Naturally I was thinking about fertility and Nature's creative force and linked these themes with a new interest in Guatemalan textiles. Using the theme of the harvest I incorporated the Guatemalan symbol for wheat with the western European style of drawing wheat. This became the outer border, between two bands of traditional geometric design. The rest of the scarf is made up of larger bunches of wheat, with the legend 'Goddess of the Earth' and the statues that appeared in the *Peace* design, which have become my symbols for the life-giving and life-protecting properties of woman.

In the *Love* design cherubs are placed in an intricate layout based on painted ceilings. I enjoy elaborately decorated ceilings, with complicated plasterwork and gilding acting as a frame for the painted image. Adapted from an existing 19th century ceiling, the *Love* design has a different cherub in each corner, and a romantic image in each side panel. In archaic Greece love was a ruthless force, and Cupid went hand-in-hand with Folly, being depicted as blind. By the Rococo era the blindfold had come off, Cupid was a younger personage and love was seen as a pleasure. The design is my Valentine to Colin and Oliver.

The *Ocean* design was inspired by a fancy dress party in Brighton, thrown by the painter Gerald Mynott, called 'Marine Parade'. One reveller came as a double-tailed mermaid. This set me thinking about the mermaid myth. The sea has always been associated with women, as has its ruling planet, the moon. Sirens and mermaids represent the fatal lure both of the seas, and of sexual obsession. They are very powerful archetypes that exist in most cultures and although female, like the gorgons, they

Ocean
Designed 1989
36 inch silk twill, ten
colours, three
colourways, acid
dyes, scarf format.

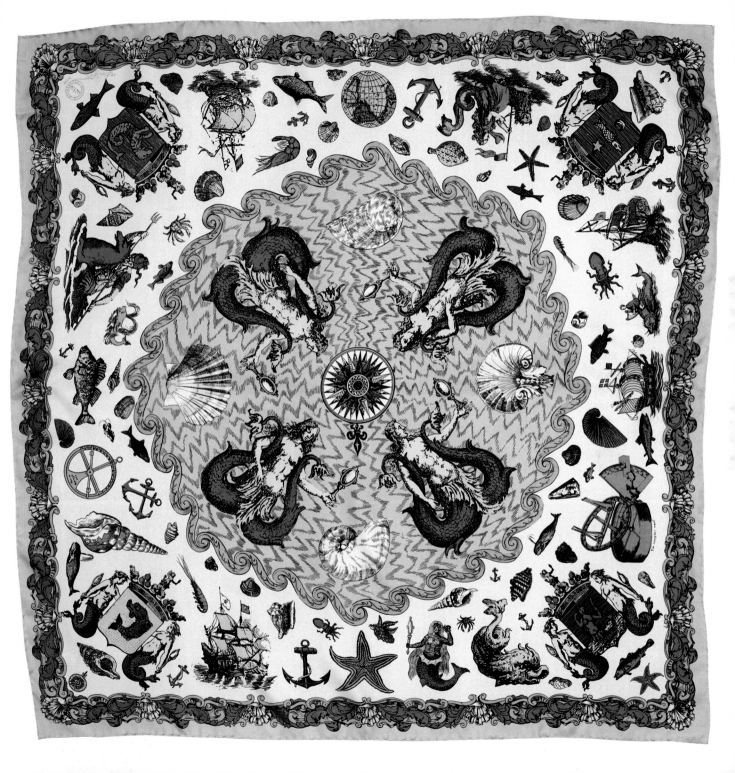

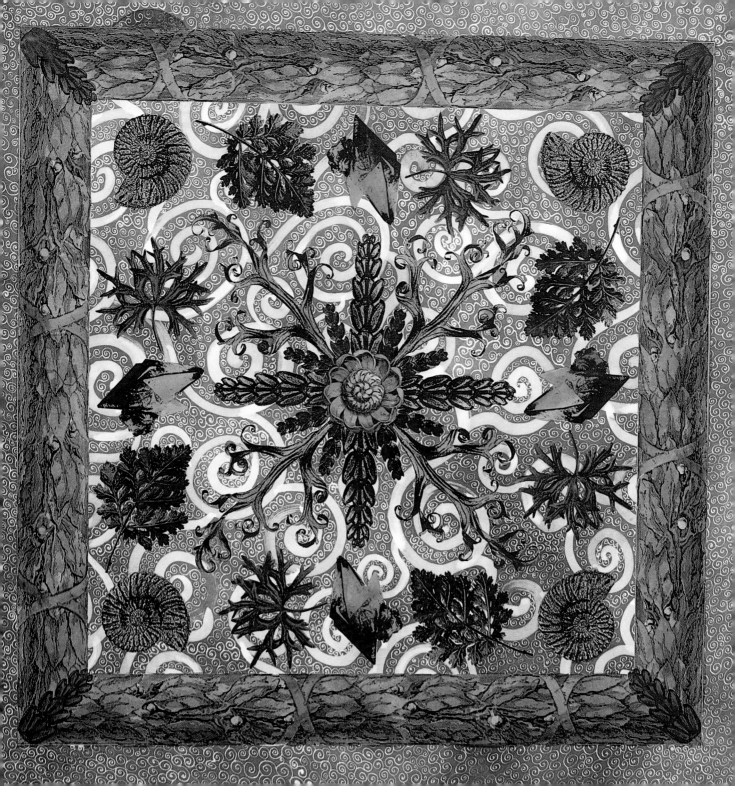

**Ink drawing for
Gaia
Designed 1990**

can conquer a man. Sailors on long journeys were so frustrated that they even 'saw' mermaids in the bodies of porpoises. Mermaids, despite their allure and narcissism, were sexually unavailable, having no place for sexual organs. The Victorian mermaid only had one tail, but earlier images, such as the renaissance ones in this design, sometimes had a double tail that hinted at legs and a more human physiology.

The design mixes maritime mythology – sea-monsters from old maps and renaissance mermaids – with antique naval equipment as found in specialist books – compasses, sea astrolabes and anchors. Fish, shells and ships complete the imagery. Each corner has a slightly different heraldic device supported by two mermaids, and the multi-coloured border features shells and leaves.

Gaia is the ancient name for Mother Earth. It encompasses both the creative and the destructive forces of Nature. The term has recently been popularized by Jim Lovelock who believes that for the survival of the planet it is essential to see it as a single living organism. His views on ecology and pollution are radical and controversial because he insists on the global vision and that Gaia is not a passive element but is seen as being able to fight back when threatened. The theory derives from an almost mystic viewpoint, but is backed up by scientific data. The *Gaia* design supports this view of Mother Earth, celebrating the eternal state of flux of Nature and the order that she creates from the chaos of life. The design features photographic images of leaves and ferns (from the vegetable world) and crystals (from the mineral world) with a fossil, which spans both kingdoms. The background is made up of spirals drawn with bleach on an ink ground. A perfect spiral is mathematically the same as the spaces between nodes on a twig. The layout is inspired by a kaleidoscope image. The border is a thick band of olive, the peace plant, tied about with ribbons at each side. This design is the most recent work in this book.

Curriculum Vitae

1955
Born Brighton, Sussex

1966–72
Brighton and Hove High School for Girls

1972–74
Eastbourne College of Art and Design

1974–77
Camberwell School of Art and Crafts

1977
1st Class BA Honours degree

1977–78
Postgraduate studies at Camberwell and St Martin's School of Art

1978-79
Freelance designing for Peppermint Prints

1979–80
Started Personal Items design company with Judy

1980–84
Part-time lecturing in fashion/textiles

1982
Printing in Wapping; began to use name 'English Eccentrics'

1984
English Eccentrics became a limited company

1987–90
English Eccentrics shop in Fulham Road, London

1988–90
External assessor in Textiles at Glasgow School of Art

1989–
Visiting lecturer in Textiles at R.C.A.

Exhibitions and Commissions

1977
Texprint, show as student designer, London

1979
British Designer Show, Olympia, *Personal Items*

1980
British Designer Show, Olympia, *Personal Items*

1983
English Eccentrics collection shown in Academy, Kings Road, London

1983
October, *Mad Dogs and Englishmen* collection at Olympia in Lesley Goring's Young Designer Show

1984
March, *Glam* collection at Olympia, designed with Claire Angel and Judy Littman

1984
September, *Hands* collection, design team as above, shown in New York

1984
October, *Gaudi* collection, design team as above, shown at Olympia

1984
November, *London Goes to Tokyo* show in Hanae Mori Building, Tokyo

1984
December, *Performing Clothes* show at the Institute of Contemporary Arts, London

1985
March, first catwalk show, *Arctic*, directed by Mark Connolly, design team as above

1985
October, *Southern Comfort* catwalk show, designed and directed as above

1985
October, show in Pitti Palace, Florence, for *Innovators in Fashion*

1986
March, *Dada* catwalk show, designed and directed as above

1986
April, *British Design*, in Vienna

1986
September, *Freudian Slips* exhibited as part of *Les Halles* group in Paris Prêt-à-Porter

1986
October, *Freudian Slips* show, Criterion Brasserie, London, designed and directed as above

1987
March, *City Monsters* show, Olympia, London, designed and directed as above

1987
March, *British Designer Menswear Show*, Kensington Exhibition Centre, London

1987
October, *Venezia* show, Olympia, London, designed and directed as above

1987
Liberty Scarf Exhibition, London, featured *Peace Women* scarf

1988
Imperial War Museum, London: Peace Studies Room featured *Peace Women* scarf

1988
January, *British Designer Exhibition* in Tokyo

1988
March, *Spirit of the Forest* collection, British Fashion Week, design team as above

1988
October, first scarf-based collection at Olympia

1989
March, scarf-based collection at Olympia

1989
September, scarf-based collection shown at Coterie, New York

1989
British Design, New Traditions, exhibition at the Boymans Museum, Rotterdam

1989

October, scarf-based collection shown in LDC group at Olympia

1989

Scarf commissioned by the Royal Academy, London

1989

Textiles in 20th century collection at Victoria and Albert Museum, London

1990

Scarf commissioned by the Royal Pavilion, Brighton

1990

Clothes used by the Ballet Rambert for *Dealing with Shadows* ballet

1990

Scarf commissioned by the Girl Guides Association

1990

Scarf and clothing commissioned by Joseph

1990

Scarf commissioned by Harvey Nichols

1990

Collecting for the Future exhibition at the Victoria and Albert Museum, London

1990

Textiles in 20th century collection at Art Institute of Chicago, USA

Thank you for your creativity and enthusiasm, Catherine, Tom, Diana, Mike and Barbro, Robin and Geoff. Thanks for your patience and support, Colin and the EE team.
Special thanks to Kurt Hutton of Gasmey, and Hankyu Department Stores Inc.

First published in 1992 by
Phaidon Press Limited
140 Kensington Church Street
London W8 4BN

© 1992 Phaidon Press Limited

© 1992 Helen Littman
© 1992 Introduction
 Catherine McDermott
© 1992 Textile designs
 Eccentric Clothes Ltd
© Fashion photography
 Robin Kiashek and
 Geoff Brightling
© Photograph pp 24-25
 Hannes Smidt

British Library Cataloguing
in Publication Data A CIP
record for this book is available
from the British Library

ISBN 0 7148 2915 3

Art direction:
Carroll, Dempsey & Thirkell
Design: Barbro Ohlson

Linotronic: Alphabet Set
Set in Monotype Baskerville
and Franklin Gothic

Reproduced, printed and bound
in Hong Kong